PUB DOGS
OF MANCHESTER

PUB DOGS
OF MANCHESTER

*Portraits of canine regulars in
the city's world famous hostelries*

GEORGIE GLASS
WITH POETRY BY GRAHAM FULTON

**FREIGHT
BOOKS**

First published in the UK, 2015

Freight Books
49-53 Virginia Street
Glasgow, G1 1TS
www.freightbooks.co.uk

A CIP catalogue reference for this book is available from the British
Library

ISBN: 978-1-910449-55-4

Typeset by Freight in Trump Gothic East & FS Clerkenwell
Printed & bound by Hussar Books, Poland

the publisher acknowledges investment from
Creative Scotland toward the publication of this book

FOREWORD BY GEORGIE GLASS

The first dog I photographed for the book was Maddie an old, extremely blind and deaf miniature schnauzer, who was also one of the loveliest dogs I have ever met. I remember carrying this cute (but slightly overweight) pooch around the pub, trying to get her to sit and stay for her portrait, thinking 'what have I got myself into here?' Little did I know this was only the beginning of the most challenging project of my life.

Challenging but also the most rewarding. Never in my wildest dreams could I have expected the response I got to this book. 82 beautiful dogs and 37 dog-friendly venues later, it seems Manchester has been waiting for a doggie guide for some time. So now I bring you one in the form of a quirky go-to guide to all the watering-holes of the city. You will never have to scour Google again to find a dog-friendly venue for your Saturday night expeditions!

All the dogs in this book are 100% authentic Pub Dogs of Manchester and could probably take you on a cracking pub crawl if you asked them nicely, with a pocket full of treats and a belly rub on hand for a befuddled taxi ride home. Also all the pubs included in this Dog-Manc bible were dog friendly at the time the photographs were taken. I am sure there are more places than I have included. So let this book mark the start of your exploration of dog-friendly Manchester! I hope it opens your eyes to our amazing city and is the start of a fantastic journey.

But coming full circle, I look back in hindsight and think it was totally worth hauling Maddie around that pub, as it was worth ever puddle of beer I knelt in and every slobber of saliva I mopped up for every single photograph, because now we have this, this guide to dog friendly Manchester. Where we can go with our pooches and their landlords will be ready with open arms! I give you Pub Dogs of Manchester. Thank you doggies and dog owners alike who took part in this labour of love. I hope you enjoy reading this book as much as I enjoyed creating it for you.

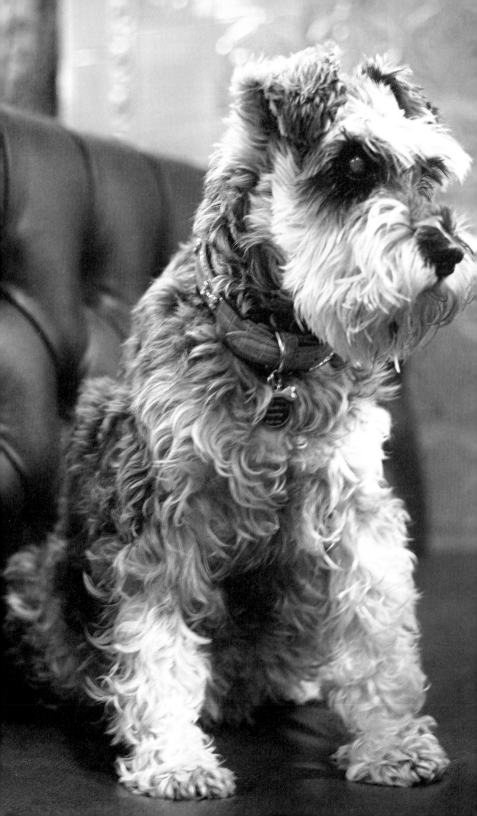

MADDIE

MR THOMAS'S CHOP HOUSE

Miniature Schnauzer

Where do they sleep?
on the sofa or, if she's good,
in bed with her brother

Favourite things
sniffing around in the park for
food or getting her neck scratched

Most dislikes
Jack Russels because they're
snappy when she's only being
friendly! Sitting on dad's lap;
she prefers to sit NEXT to him

Favourite place
Didsburry Park or her bed,
under the radiator

Favourite drink
milk, but she's diabetic
so she's not allowed it

When not in Pub likes to
sleep, all the time

Likes cats or loathes cats?
LOATHES with a vengeance

Best trick
walking on her hind legs to get
nearer to food!

Favourite toy
she likes everything but never
knows what to do with it when
she has it

Favourite treat
bread, but she had too many treats
and now she's diabetic... oops

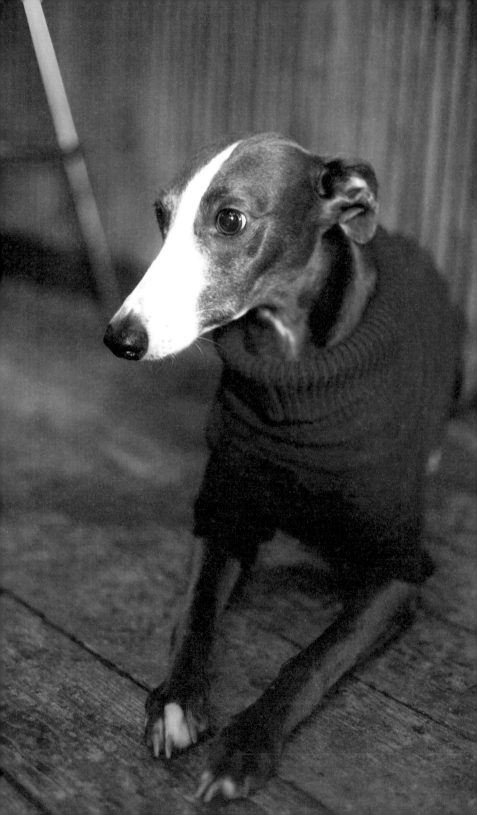

SKYLAR VOLTA

Whippet

Where do they sleep?
under the nearest duvet, preferably
snuggled up to a human

Favourite things
breakfast in bed, chasing squirrels
and running at speed!

Most dislikes
the cold, cats

Favourite place
behind the sofa, next to the radiator

Favourite drink
cold tea (mine!)

When not in Pub likes to
sleep/run/eat

Likes cats or loathes cats?
likes chasing cats

Best trick
figure of 8 though my legs

Favourite toy
squeaky pigeon

Favourite treat
tripe

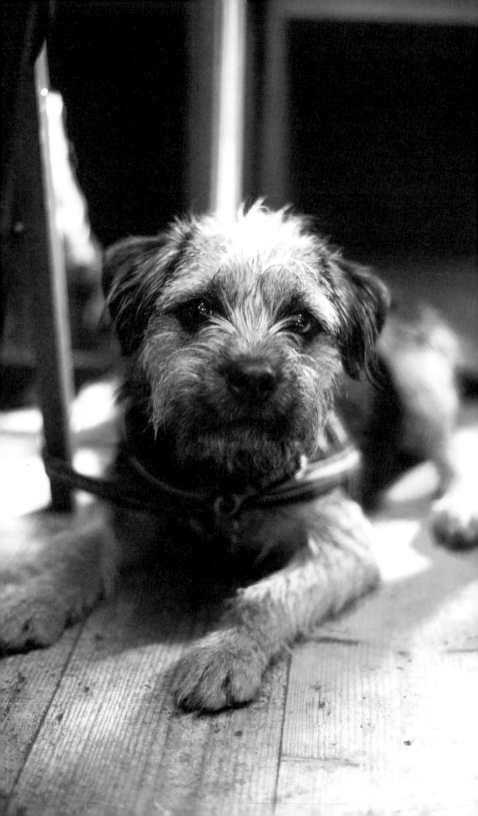

RALPH

VOLTA

Border Terrier (mostly)

Ralph's Deduction

Hello.
I'm Ralph.

I'm a Border Terrier, 'Mostly'.

It's that word 'Mostly'
which is bothering me.
'Mostly' implies
I'm 'Partly' something else.

One tenth Chihuahua?
One fifth Rottweiler?
Who knows?

Actually,
Andy Murray knows.
He's got two Border Terriers
he talks to regularly on Skype.
I think he rejected me
because I'm
one sixth Novak Djokovic.
The fruit of his
sweaty bestial attentions,
the offspring from
his forehand slice.

I'm a Baskerville throwback.
The real heir
to the Murray Millions.
A sponsorship deal,
an endless supply of sausages.

I spit on
your Novak Djokovic
with his
never-growing Serbian hair
and his
bendy Gluten Free physique!

Oh well,
I suppose it could be worse.

It could have been Boris Becker
or John McEnroe.

YOU CANNOT BE SERIOUS!

RALPH

Where do they sleep?
sofa

Favourite things
playing with other dogs and
destroying his toys

Most dislikes
Henry the hoover

Favourite place
anywhere his humans are

Favourite drink
water – also in ice cube form!

When not in Pub likes to
stalk other dogs in the park

Likes cats or loathes cats?
pretends to not see cats –
prefers chasing leaves

Best trick
roll over

Favourite toy
Owly the squeaky owl

Favourite treat
sausages

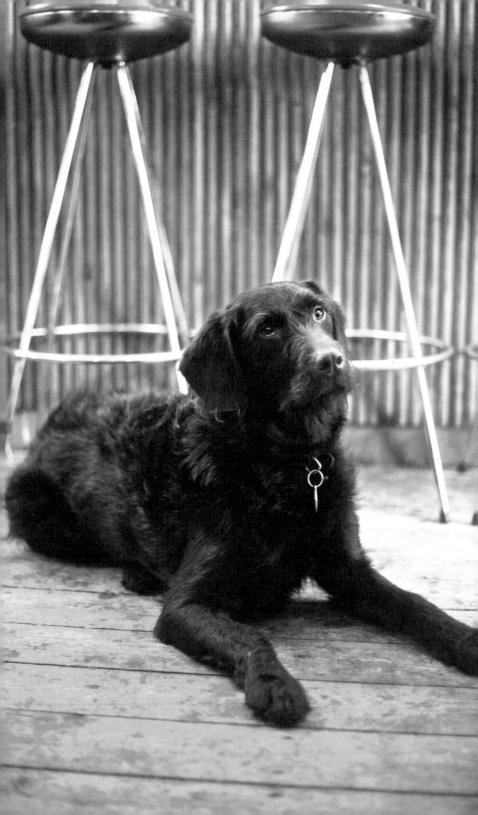

YORKIE

VOLTA

Labradoodle

Where do they sleep?
anywhere and everywhere;
comfortable using display pillows
and cushions, equally happy to
sleep on wooden and stone floors

Favourite things
food, snow, rivers and ponds,
Frisbees, people

Most dislikes
rain, despite loving swimming
in rivers and ponds in minus
temperatures

Favourite place
home

Favourite drink
rain water

When not in Pub likes to
chase Frisbees, balls, cats,
dogs...anything!

Likes cats or loathes cats?
likes to chase them

Best trick
his ability to get food out of just
about anyone – a sit, a head tilt
and a paw seals the deal

Favourite toy
slippers and socks

Favourite treat
biltong – a south African dried,
cured meat (though he doesn't
get it very often!)

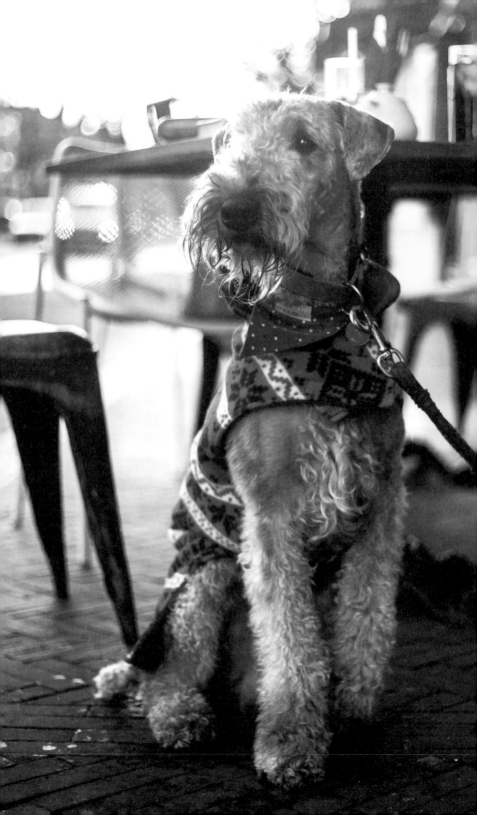

RALPH

THE VIOLET HOUR

Airedale

Ralph's Name

I've got a name
that sounds like a bark.

RALPH! RALPH!

See what I mean.

I'd rather be
like Clint Eastwood.
The Dog With No Name.

I've already got the poncho,
the strong silent gaze.

I could run around
under blue Spaghetti skies,
yapping at Mexicans
and Lee Van Cleef.
Biting Eli Wallach
with my nice sharp teeth.

I could make movies called
A Fistful of Liver.
For a Few Chicken Sticks More.
The Ralph, The Bad,
and The Ugly.

High Plains Piddler
with an Ennio Morricone score.

I can hear the tumbleweed.
Taste the breeze.

Never mind.
It's not meant to be.

Ralph – The Dog With A Name,
doesn't really
sound the same.

And Didsbury isn't Arizona.

RALPH

Where do they sleep?
on the landing, outside our
bedroom

Favourite things
walks, treats, being fussed over

Most dislikes
cats

Favourite place
Fountain's Abbey, North Yorkshire

Favourite drink
water

When not in Pub likes to
visit family and get spoilt

Likes cats or loathes cats?
loathes

Best trick
not exactly a trick but... Ralph's
always looking up at the sky
(a thing I though dogs didn't do)
as if checking out bird migration
cycles, patterns in the clouds,
maybe alien invasion...

Favourite toy
squeaky bone

Favourite treat
liver

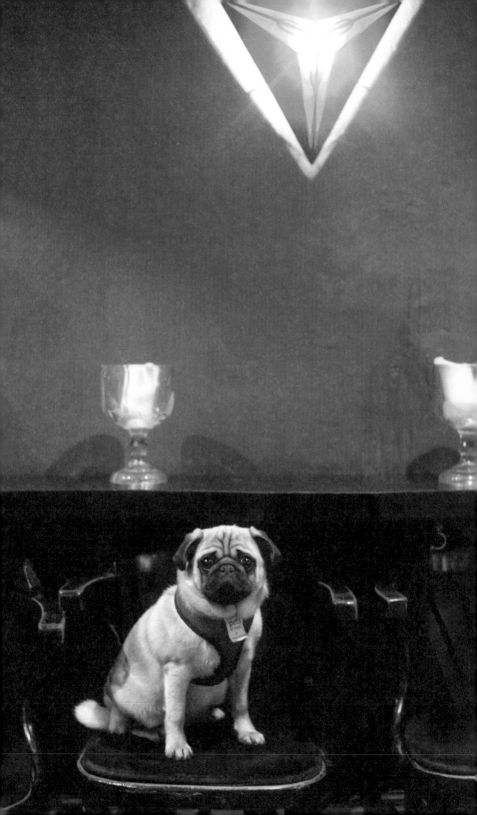

PEARL

BEGGAR'S BUSH

Pug

Where do they sleep?
in a dog bed

Favourite things
food and the cat

Most dislikes
unfriendly dogs

Favourite place
Beech Road Park

Favourite drink
puddle water

When not in Pub likes to
rampage around the park

Likes cats or loathes cats?
likes

Best trick
ambush big dogs from
under the park benches

Favourite toy
knotted rope

Favourite treat
leg of lamb bone

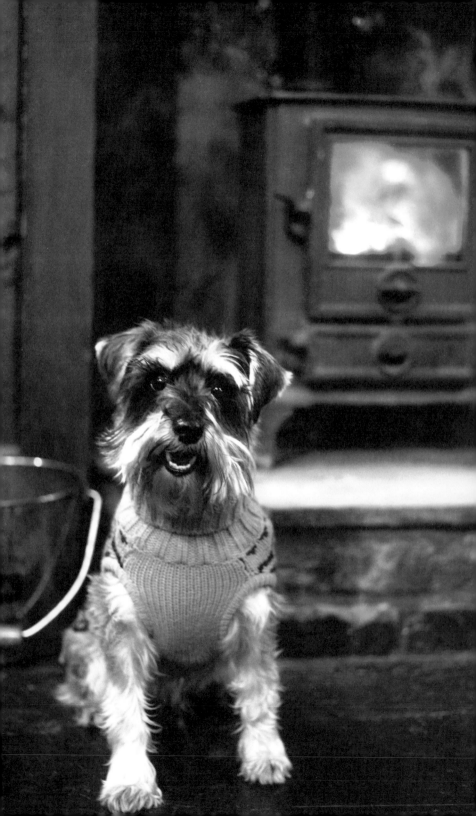

HARVEY

DOG & PARTRIDGE

Snorkie

Where do they sleep?
in his bed or on the sofa

Favourite things
treats and walks

Most dislikes
cats and getting wet

Favourite place
bed or basking in the sun

Favourite drink
water and cups of tea

When not in Pub likes to
going for long walks along
the river Mersey

Likes cats or loathes cats?
loathes

Best trick
crawling along the floor

Favourite toy
squeaky dog

Favourite treat
dental sticks and bones

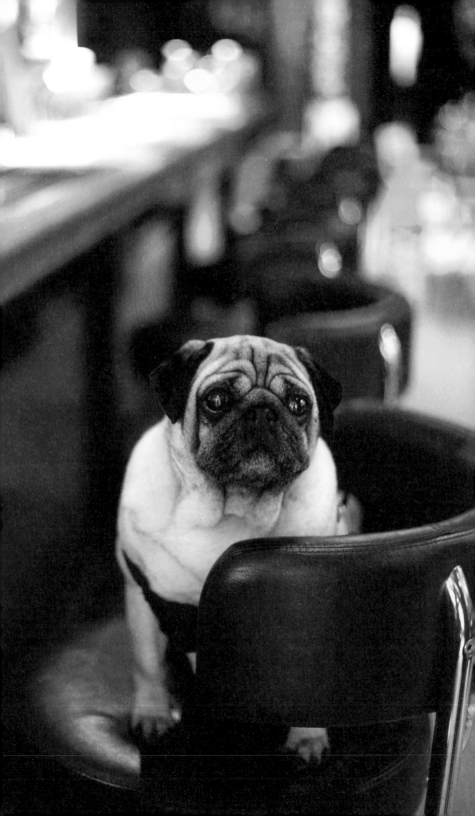

MOLLY

NIGHT & DAY

Pug

Where do they sleep?
bottom of the bed

When not in Pub likes to
cuddle all day

Favourite things
food! Sleep and treats

Likes cats or loathes cats?
likes

Most dislikes
people not sharing food, rain, snow

Best trick
gives the big eyes for food

Favourite place
middle of the bed

Favourite toy
doesn't really play, prefers to cuddle

Favourite drink
water

Favourite treat
anything and everything!

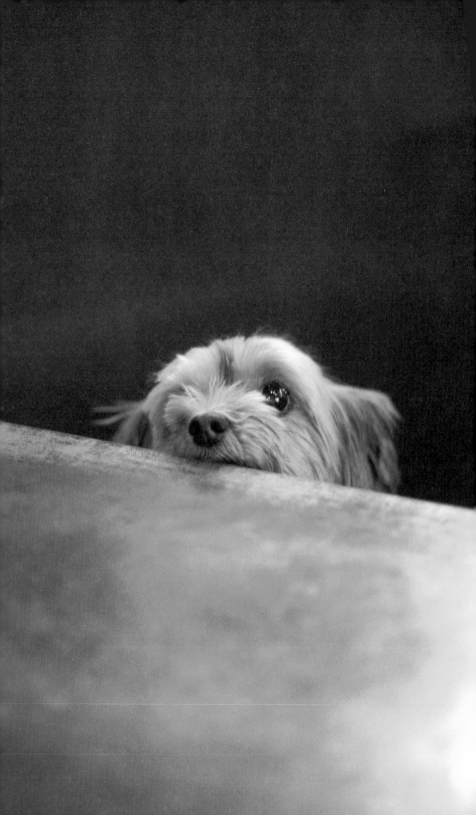

WILLOW

BREWDOG

Yorkie

Where do they sleep?
everywhere, but especially
at the back of the sofa

When not in Pub likes to
sit by the window with all
the other (and larger) cats

Favourite things
dirty socks and taking tissues
from the box

Likes cats or loathes cats?
only likes Monty, he's a great
neighbour

Most dislikes
being woken up, she's a
grumpy lady after 7pm

Best trick
hiding in the bed when she's
been naughty

Favourite place
the Lake District

Favourite toy
anything fluffy

Favourite drink
puddle water or unguarded
cups of tea

Favourite treat
chicken from the Sunday roast

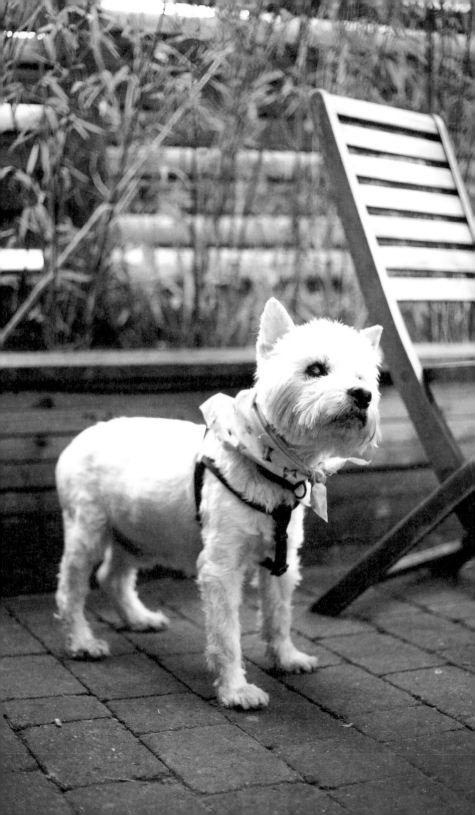

MILO

FOLK

Westie

Where do they sleep?
in their basket

When not in Pub likes to
relax on the sofa

Favourite things
walks with his dad

Likes cats or loathes cats?
loathes

Most dislikes
bumping into things

Best trick
paw

Favourite place
the local pub

Favourite toy
usually anything he can't have

Favourite drink
water

Favourite treat
something diabetic friendly

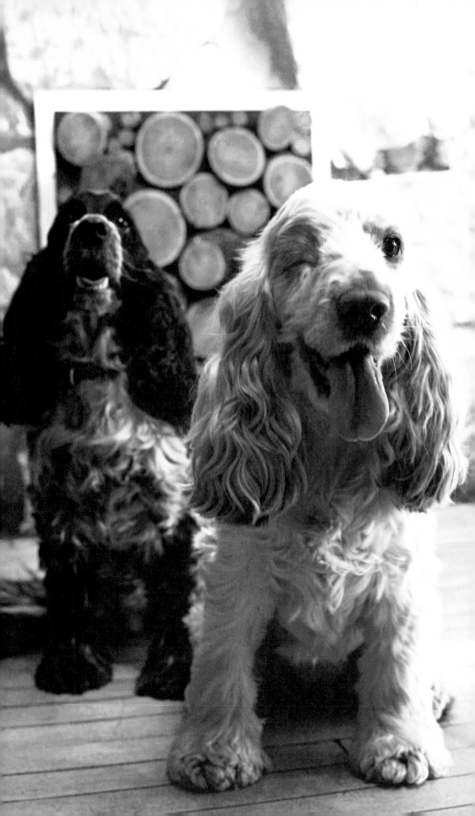

RUBY & HONEY

FOLK

Cocker Spaniels

Where do they sleep?
in the middle of the bed
between Mum and Dad

Favourite things
carrying socks around the house

Most dislikes
discipline

Favourite place
sitting on the back of the sofa like
two sphinx barking at the postman

Favourite drink
water, preferably dirty

When not in Pub likes to
bark, sleep, bark, eat and bark

Likes cats or loathes cats?
barks at all cats so not sure...

Best trick
barking

Favourite toy
socks and / or knickers...

Favourite treat
digestive biscuits

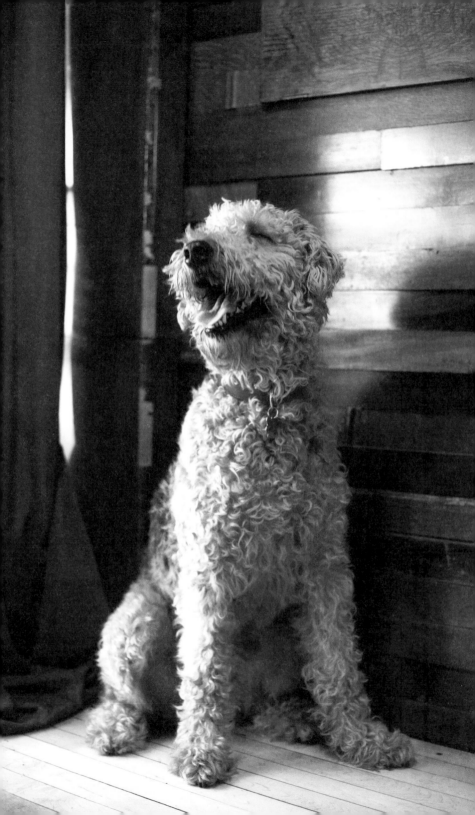

CHARLIE FOLK

Airedale

Charlie's Tap

Look at me!
I'm dancin'! I'm dancin'!

or at least I would be
if I could dance.

In fact,
I think I'm rather nifty at tap
with my top hat and tails,
my LA spats.

A doggy-style Fred Astaire.
A Mad Mutt Lionel Blair.

I could appear on Strictly —
step on a High One's toes,
do the Foxtrot, the Jive,
the American Smooth.
I could have my fur curled
in the backstage dressing room,
be fed digestives
at regular intervals.

I could have a fling with Kristina,
be photographed leaving
at six in the morning.

Demand to have
my phone tapped.
Give evidence at an inquiry
into tabloid intrusion.

Gangway Winkleman,
here I come!
My paws are a blur.
My nose is a nose.
It doesn't matter that I'm a girl.

Look at me!
I'm dancin'! I'm dancin'!

CHARLIE

Where do they sleep?
she has her own single bed

Favourite things
the noisiest toy in the box

Most dislikes
ponds

Favourite place
front window, on guard

Favourite drink
water from the hose pipe

When not in Pub likes to
chill in the garden,
any weather will do

Likes cats or loathes cats?
play time!

Best trick
tap dancing

Favourite toy
wet bathroom towel

Favourite treat
digestive biscuits

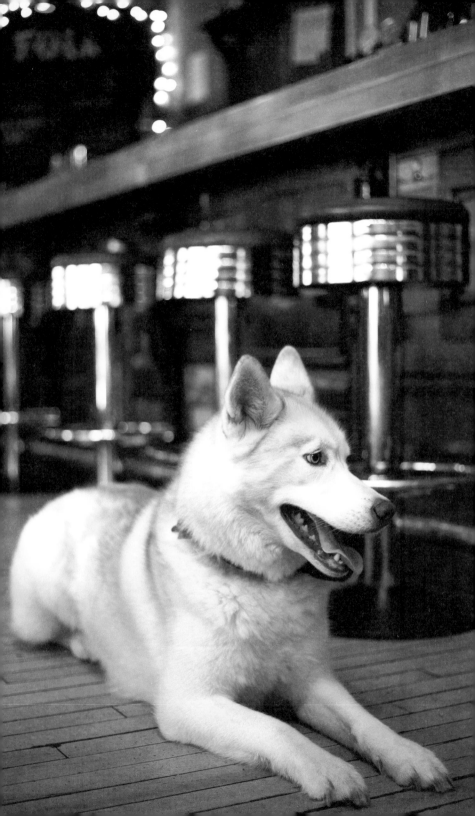

LOGAN

FOLK

Husky

Where do they sleep?
on the chaise longue

When not in Pub likes to
sleep

Favourite things
dog teddy she uses as a dummy

Likes cats or loathes cats?
loves cats, licks them when
she manages to get close

Most dislikes
being on a lead

Best trick
"give me your paw"

Favourite place
the garden

Favourite toy
Kong treat dispenser

Favourite drink
water (would prefer
outdoor dirty water)

Favourite treat
Schmackos

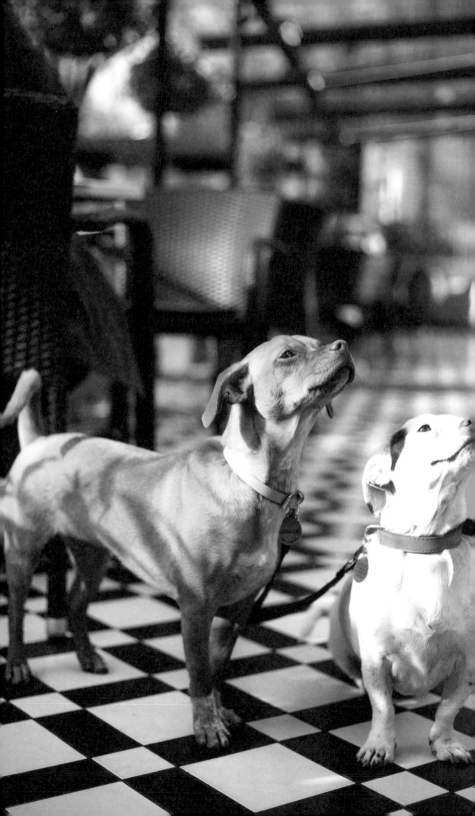

LULA & GINGER

ALBERT'S SHED

Mix

Where do they sleep?
everywhere!

Favourite things
sausages, chasing squirrels,
long walks on the beach!

Most dislikes
irritating squirrels, dogs on TV

Favourite place
beer gardens, the beach

Favourite drink
Ginger loves beer foam!

When not in Pub likes to
fart and walk away, steal food,
eat shoes

Likes cats or loathes cats?
Lula rules the roost: no cats!
Ginger plays with cats

Best trick
making cheese disappear

Favourite toy
fluffy stuffed toys

Favourite treat
chicken sticks, Bakers Allsorts

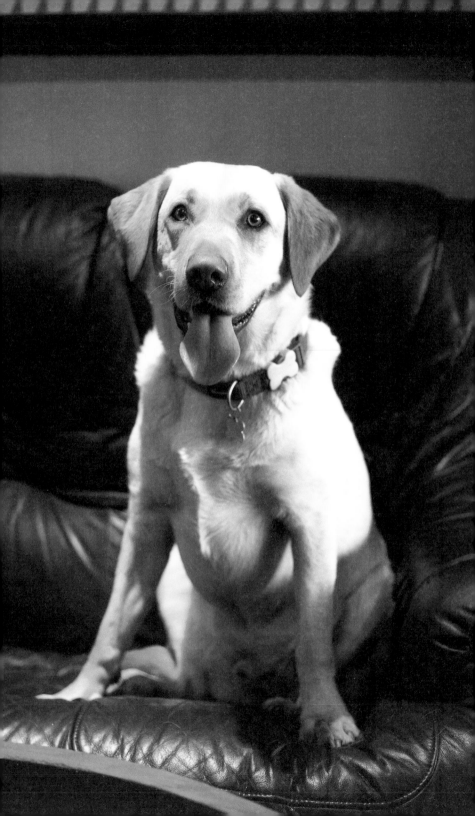

BATMAN THE FONT

Labrador

Where do they sleep?
in his bed, in my bedroom

When not in Pub likes to
swim

Favourite things
swimming! Sticks, Sunday roast,
walkies and acting like a human

Likes cats or loathes cats?
indifferent

Most dislikes
people thinking he's a dog

Best trick
gives kisses

Favourite place
Sunnyhurst woods

Favourite toy
tennis ball

Favourite drink
water

Favourite treat
ham

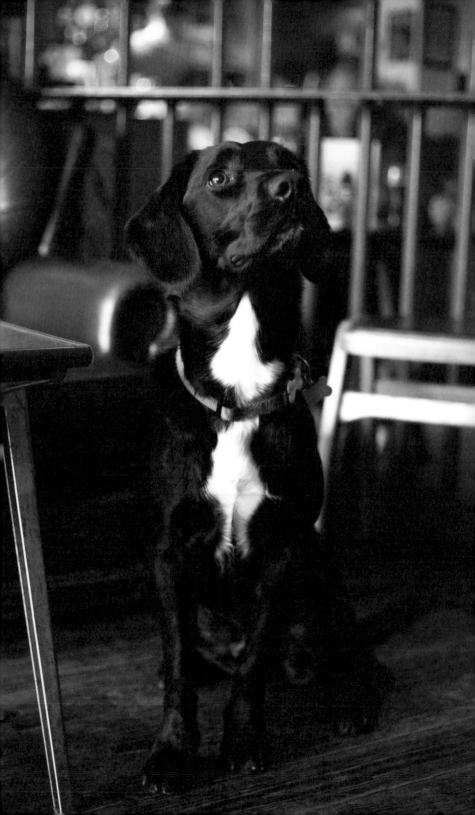

ELMO

THE FONT

*Cockerdor (Labrador x
Cocker Spaniel)*

Where do they sleep?
in his bed in my bedroom, but tries
his best to get into the real bed

Favourite things
cuddles and Sunday roasts

Most dislikes
metal bowls, hoovers, hairdryers,
tool boxes, unfamiliar objects
in familiar places, big grey
dogs, noises

Favourite place
somebody's knee

Favourite drink
water

When not in Pub likes to
explore – he thinks he's Bear Grylls

Likes cats or loathes cats?
he's scared of them

Best trick
going cross-eyed

Favourite toy
socks

Favourite treat
cuddles

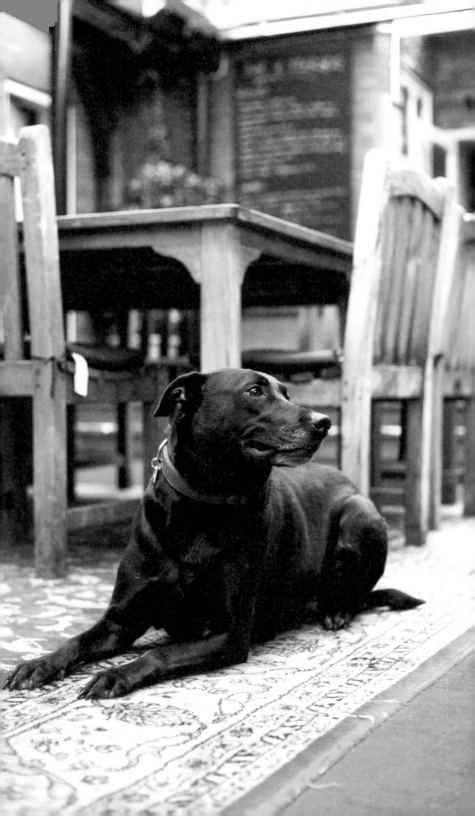

OLIVE

THE METROPOLITAN

Labrador and Collie cross

Where do they sleep?
at the foot of the bed

Favourite things
sitting on the couch

Most dislikes
wheelie bins

Favourite place
the park

Favourite drink
muddy puddles

When not in Pub likes to
play follow the leader
(where you go, I go)

Likes cats or loathes cats?
scared

Best trick
giving you the "puppy dog" eyes

Favourite toy
any teddy bear will do

Favourite treat
anything

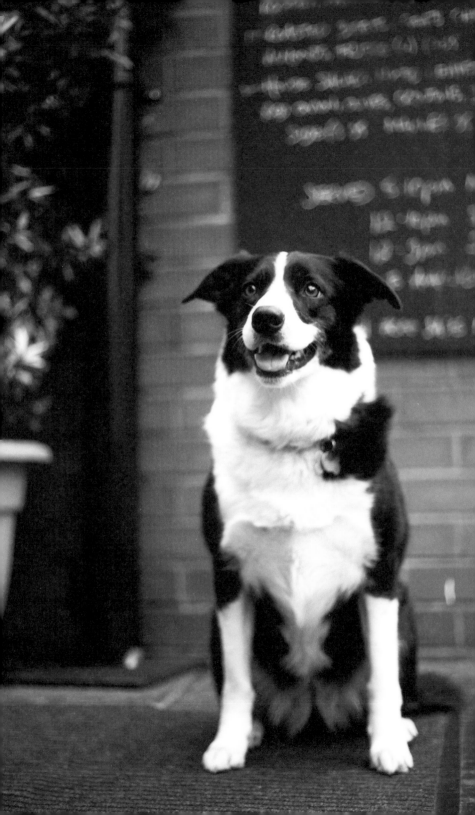

DARCY

THE METROPOLITAN

Welsh Collie

Where do they sleep?
snuggled next to humans
on the bed

Favourite things
tennis balls

Most dislikes
noisy traffic

Favourite place
under the dining room table

Favourite drink
water from anywhere
but the dog bowl

When not in Pub likes to
play fetch constantly

Likes cats or loathes cats?
likes cats

Best trick
fetch games

Favourite toy
tennis balls

Favourite treat
any!

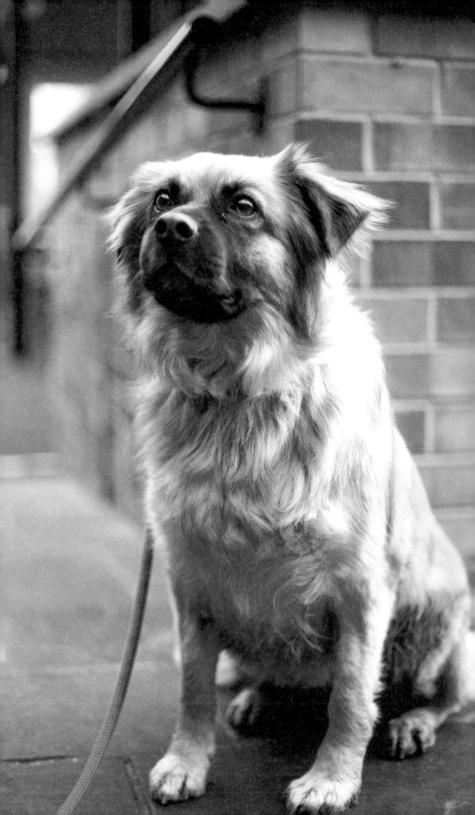

SHENZI

THE METROPOLITAN

Heinz 57

Where do they sleep?
own bed

Favourite things
Norman, a stuffed green toy

Most dislikes
being clean

Favourite place
anywhere with us

Favourite drink
water

When not in Pub likes to
run around with her friends

Likes cats or loathes cats?
lives with one – likes him

Favourite toy
Norman

Favourite treat
anything

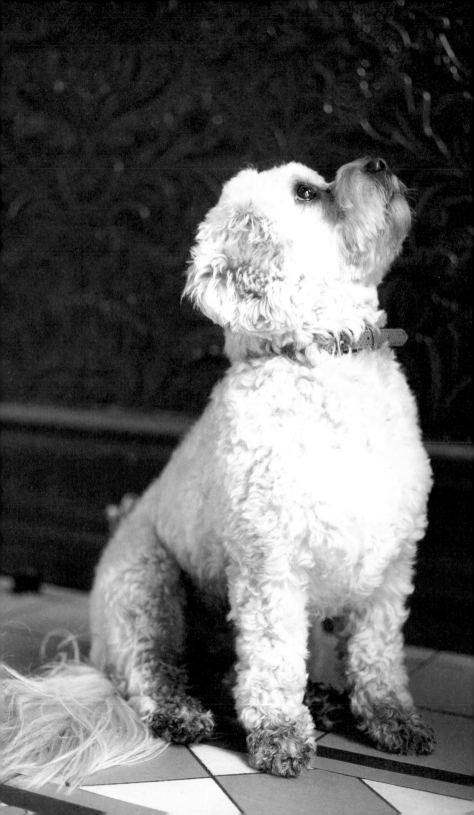

BELLE

THE METROPOLITAN

Cavapoo

Belle's Heaven

I love to look at the sky.
The birds, the sun,
the twinkles,
the moon.

Something beyond
the same routine.
Running in the park,
dancing with my mates.
Barking at postmen,
chasing leaves.

There's nothing wrong
with that

yet I need to believe
there's something more.
Something above
what we think we know.

The High Ones say
they're the only ones
important enough
to sit with God.

But why can't we have
our own little cloud
where we belt around
burying haloes,
nipping the ankles of angels,
tearing the wings off cherubs,
chewing up Jesus' sandals,
jumping on Gabriel's shoulders,
humping Peter's shins,
taking a dump on a sunbeam,
walking mucky paws
through the many mansions,
playing with God's big balls
in the garden,
cocking a leg against
the pearly gates?

Golden showers.
Paradise Park.

And down in hell
the Devil's a cat.
Surely that's not
too much to ask.

BELLE

Where do they sleep?
If Belle had her choice, my
bed, but she sleeps in her own

Favourite things
chasing leaves, tug toy

Most dislikes
postman, big dogs

Favourite place
park, with her doggie friends

Favourite drink
water

When not in Pub likes to
nosey at everything

Likes cats or loathes cats?
no cats!

Best trick
sit, lie, roll

Favourite toy
soft and/or squeaky toys

Favourite treat
chicken treats

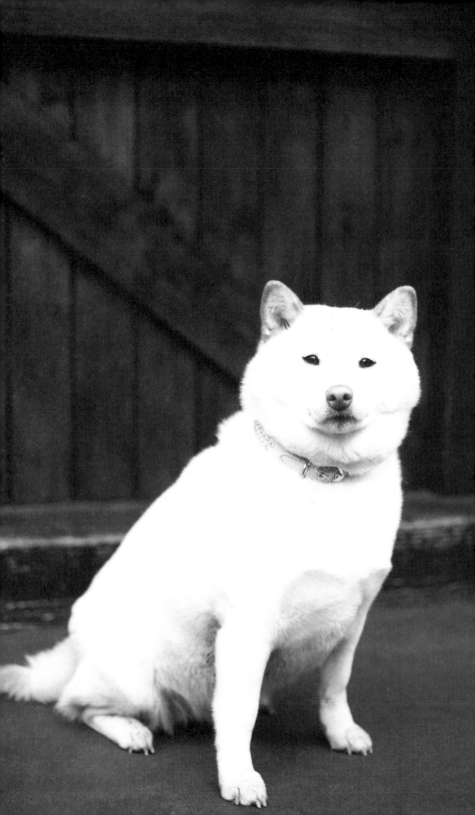

TRIXIE-DIAMOND THE METROPOLITAN

Shiba Inu

Where do they sleep?
in her bed, but has started
to creep upstairs

Favourite things
walking, jumping in cars
and continuous stroking.
Oh, and tissues

Most dislikes
baths and having her nails clipped

Favourite place
with me, playing tug of war

Favourite drink
water

When not in Pub likes to
run round with her friends

Likes cats or loathes cats?
loathes cats

Best trick
roll over

Favourite toy
little fox

Favourite treat
spaghetti bolognese

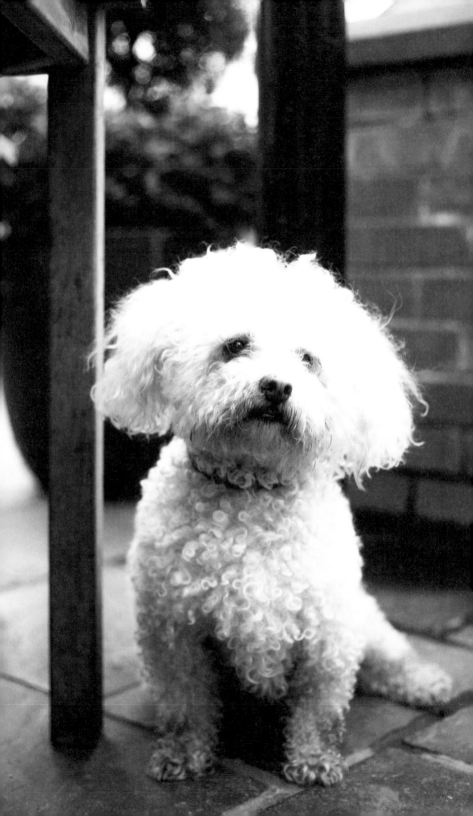

SCAMP

THE METROPOLITAN

Bichon Bolognese

Where do they sleep?
on my bed at night, the rest of
the time he has an entire sofa
where he arranges the cushions
to his comfort

Favourite things
food, food and more food

Most dislikes
thunder, fireworks and cuddling!

Favourite place
the park where he scrounges treats
off everyone by doing his cute act:
plonks himself in front of them and
smiles – he has a big smile!

Favourite drink
water

When not in Pub likes to
eat and sleep

Likes cats or loathes cats?
depends... sometimes ignores
them, sometimes chases them

Best trick
has a whole dance routine,
including twirls and can-can

Favourite toy
doesn't do toys (they're not edible)

Favourite treat
everything and anything

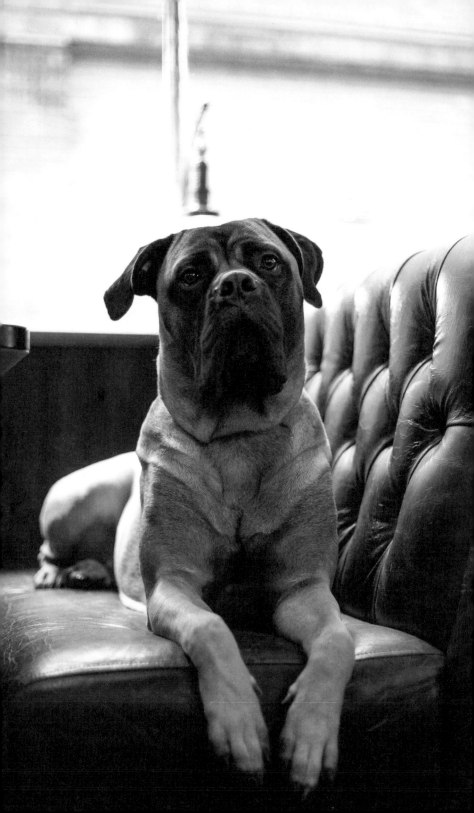

JURA

Bullmastiff

GULLIVERS

Where do they sleep?
in her (our) bed

Favourite things
goose poop, anything that belongs
to Mum and Dad

Most dislikes
will eat absolutely anything except
for basil

Favourite place
anywhere that Mum and Dad are
trying to sit

Favourite drink
Jura!

When not in Pub likes to
chase bicycles

Likes cats or loathes cats?
likes and loathes (it's complicated)

Best trick
pretending she doesn't understand
us until we're holding food

Favourite toy
anything potentially life
threatening or that doesn't belong
to her

Favourite treat
unattended dinner

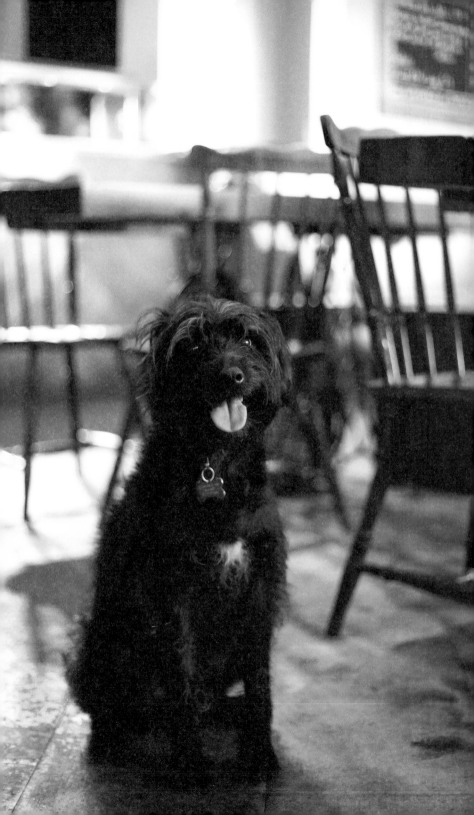

BILLY

SOUP KITCHEN

Patterdale x Border Terrier

Where do they sleep?
in our bed or on the sofa downstairs

When not in Pub likes to
be outside as much as possible

Favourite things
hunting squirrels and
shouting at cats

Likes cats or loathes cats?
'kin loathe 'em

Most dislikes
CATS!

Best trick
fetch and retrieve (terrier!)

Favourite place
running by and diving
into the river Mersey

Favourite toy
socks

Favourite treat
chicken

Favourite drink
puddle water

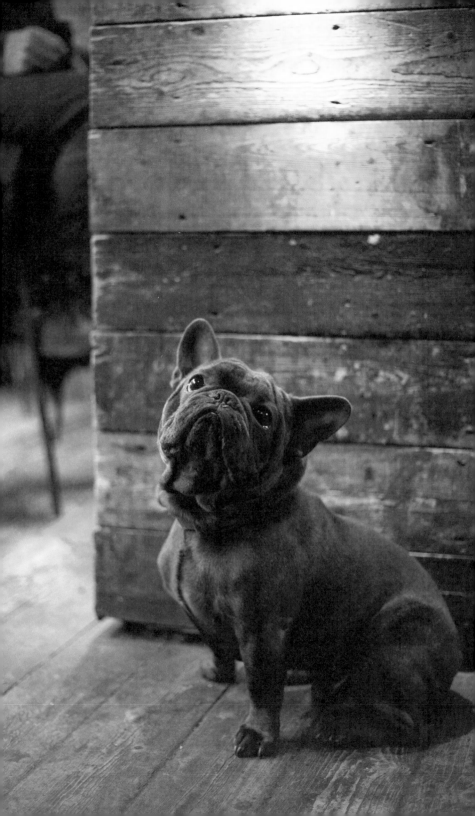

MAURICE TERRACE NQ

French Bulldog

Where do they sleep?
anywhere he likes! At the office
he has his own sofa, at home in
his basket

Favourite things
ball, ball, ball! And people.
He loves attention and expects
to be cuddled and patted

Most dislikes
not too keen on bath time to
be honest, or air vents and fans
– they scare him! Nor the vet

Favourite place
anywhere as long as it's with
his dad – best buds! Failing
that, running around on the
beach in Lytham St Annes,
his mum's hometown

Favourite drink
Tried doggy beer once and
pee'd everywhere! So sticks
to Manchester's finest
corporation pop!

When not in Pub likes to
go for walks with his folks and
play in the park, then a lot of
sleeping, snoring and trumping!

Likes cats or loathes cats?
not met that many, just
intrigued and wants to play!

Best trick
not keen on tricks, too stubborn
for that; he'll give you his paw
and stand on two legs if you
have some treats

Favourite toy
it's got to be his small robin teddy.
He carries it around the house
and sleeps with it in his basket
every night

Favourite treat
god he loves HAM! He also
likes carrots, meat is better though

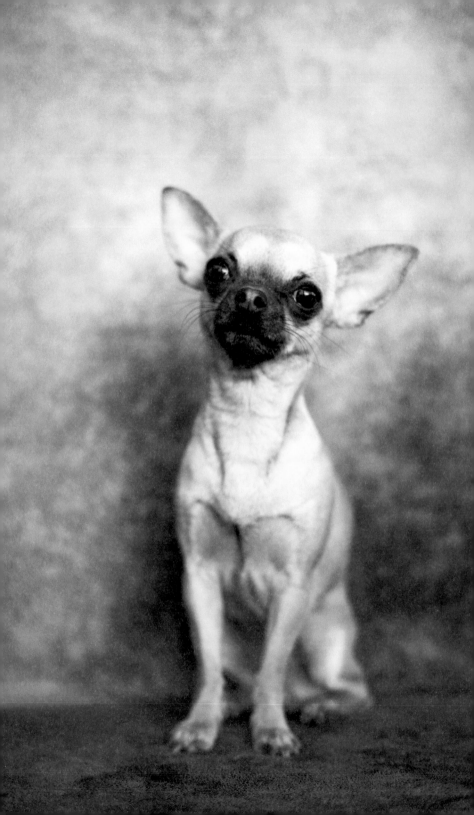

PIPPY

ATLAS BAR

Chihuahua

Where do they sleep?
in bed with Mom and Dad

Favourite things
food, food and food

Most dislikes
getting out of bed
in the morning

Favourite place
by the fire place

Favourite drink
tea (brew)

When not in Pub likes to
hang out with
Mum and Dad

Likes cats or loathes cats?
not a fan of cats

Best trick
whacking the food bowl
when it's empty

Favourite toy
Monkey

Favourite treat
Saturday morning fry-up

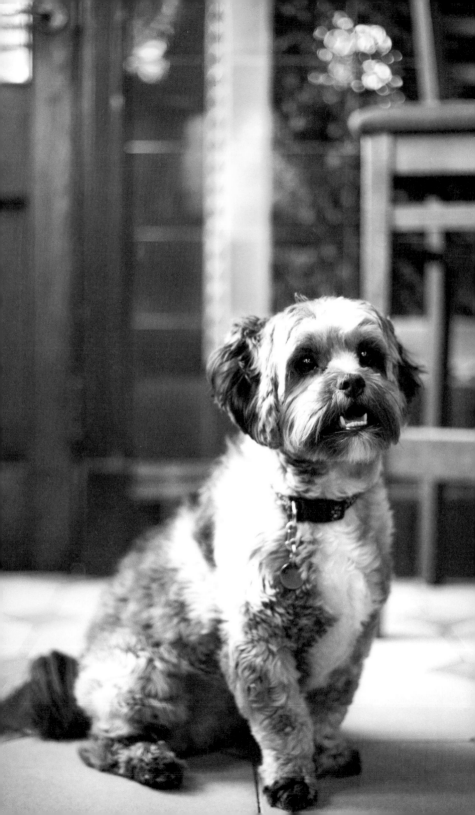

DUSTY

BRITON'S PROTECTION

Cockapoo

Where do they sleep?
in her own bed

Favourite things
treats, toys and cuddles!

Most dislikes
having a bath

Favourite place
out in the garden

Favourite drink
water

When not in Pub likes to
go for a walk, play and sleep

Likes cats or loathes cats?
still unsure, but curious

Best trick
gives a paw

Favourite toy
rubber ring

Favourite treat
sausages and cheese

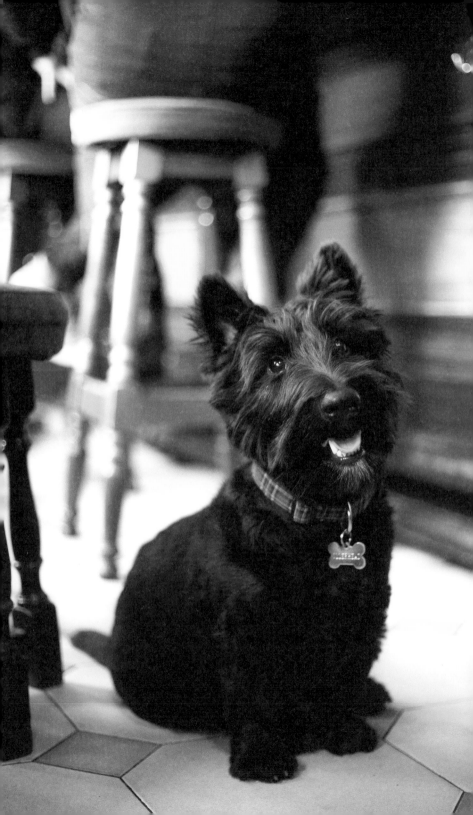

ANGUS

Scottish Terrier

BRITON'S PROTECTION

Where do they sleep?
in his tartan bed

Favourite things
walks and pull toy. Also watching
the TV. He loves anything with
Paul O' Grady; he's his hero

Most dislikes
buses, trucks – scared of them

Favourite place
on the back of the sofa

Favourite drink
water

When not in Pub likes to
visit family and chase squirrels

Likes cats or loathes cats?
loves our cat Angel but she
doesn't like him. He chases
her all over the house

Best trick
begging for treats

Favourite toy
rubber tug of war

Favourite treat
chicken and cheese

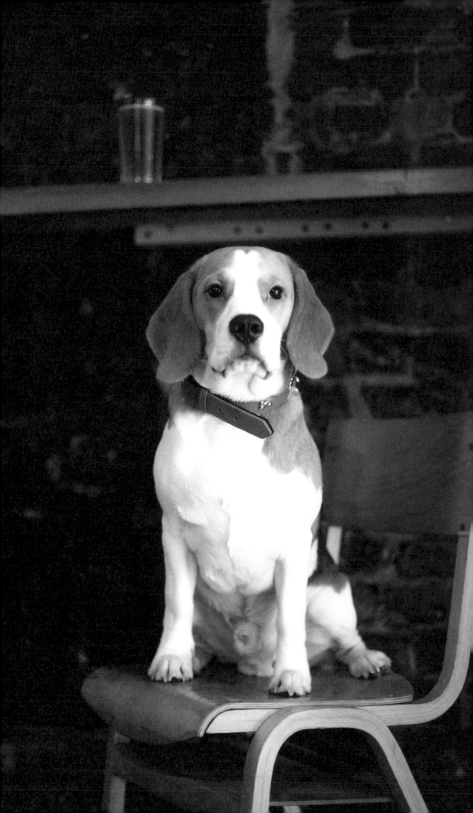

BAILEY

TERRACE NQ

Tri-coloured Beagle

Where do they sleep?
in bed between his
mummy and daddy

Favourite things
pig ears, anything foodie! People;
being the centre of attention

Most dislikes
being told off!! Being told no!!

Favourite place
my dad's. He gets treated like a king!

Favourite drink
he likes to drink the remains of
a glass of rosé wine! And tea!

When not in Pub likes to
steal slippers, chew socks
and eat brand new shoes

Likes cats or loathes cats?
Bailey is petrified of cats!

Best trick
sit, paw, lie down and roll
over (it's like a dance)

Favourite toy
Kong and Kong paste

Favourite treat
pig ears, he could eat them for hours

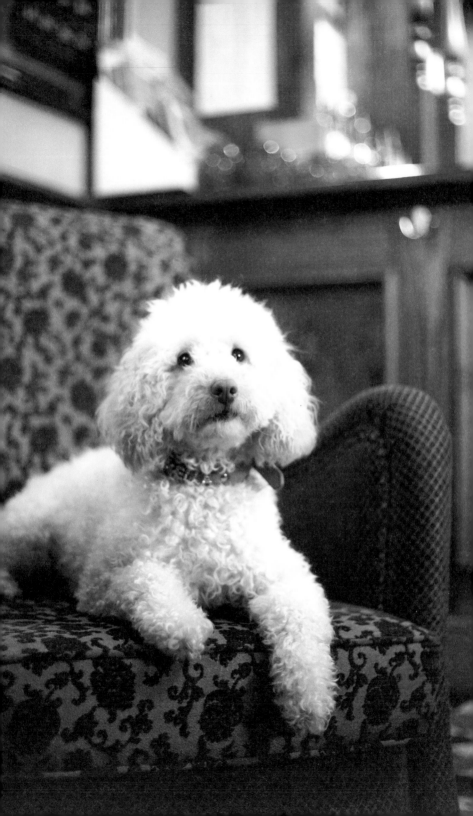

ELLA

GULLIVERS

Miniature Labradoodle

Where do they sleep?
in bed with us! Under the covers
with her head on the pillow!

Favourite things
ripping the insides of
her teddy bear out

Most dislikes
other dogs running after her

Favourite place
the park!

Favourite drink
anything that isn't meant
for her, like cups of tea

When not in Pub likes to
watch films with her dad

Likes cats or loathes cats?
loves cats! She forgets she isn't one

Best trick
high five

Favourite toy
her teddy bear

Favourite treat
any meat that she usually
takes from our plate!

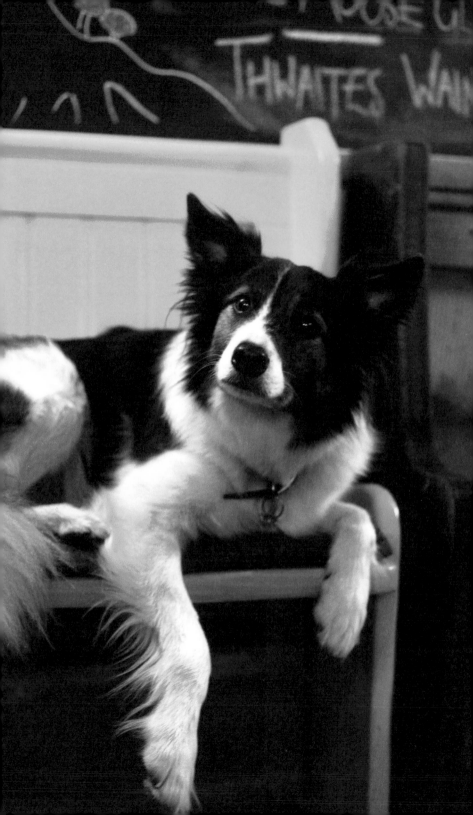

SAM

THE BEECH

Border Collie

Where do they sleep?
on the floor at the bottom of the bed

Favourite things
running, getting a fuss, playing ball

Most dislikes
cats, the vet

Favourite place
on the sofa with his legs in the air

Favourite drink
milk

When not in Pub likes to
run in the park

Likes cats or loathes cats?
loathes

Best trick
he knows his left from his right

Favourite toy
the ball

Favourite treat
the leftover yoghurt pot

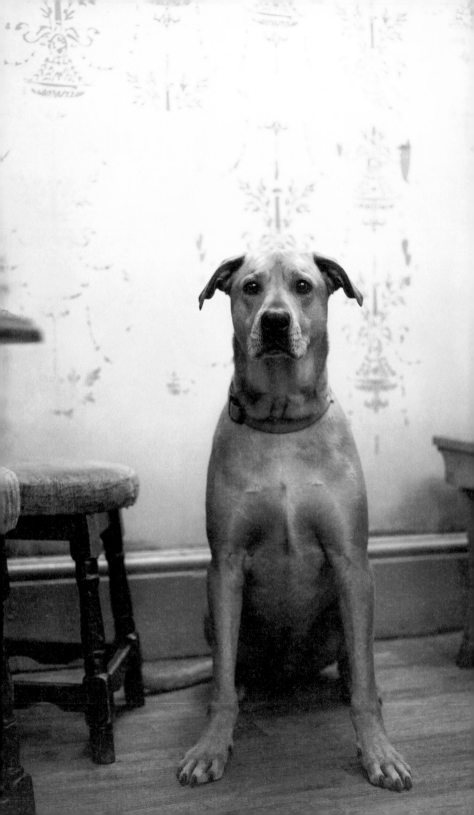

LENNIE

THE BEECH

Ridgeback

Where do they sleep?
wherever he wants

Favourite things
food, walks, running, swimming

Most dislikes
not afraid of anything now

Favourite place
pubs

Favourite drink
water

When not in Pub likes to
socialise

Likes cats or loathes cats?
would like to catch one or find one

Best trick
doesn't really do tricks. Likes
running up mountains and CaniX

Favourite toy
cuddly toys and Frisbee

Favourite treat
just about anything

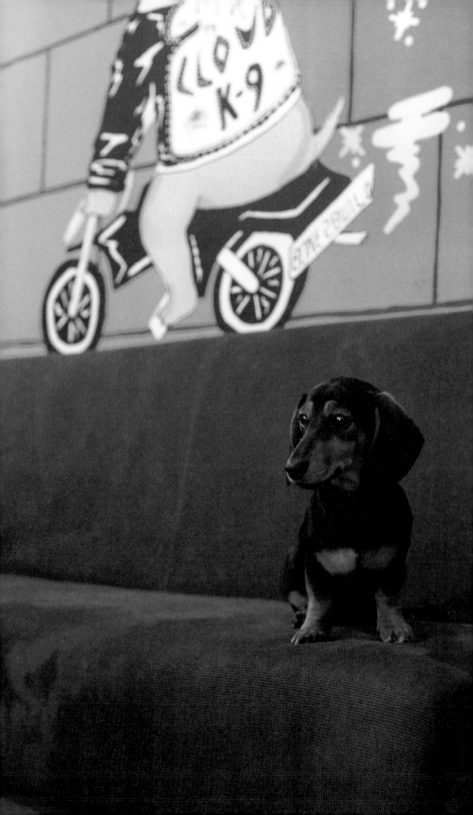

HEIDI

COMMON

Miniature Dachshund

Where do they sleep?
in an igloo bed

When not in Pub likes to
sleep

Favourite things
chasing pigeons, being spoilt

Likes cats or loathes cats?
loathes the creatures

Most dislikes
being on the lead, rain

Best trick
switching on the doe eyes to
get treats

Favourite place
a warm lap

Favourite toy
his bone, smokey bacon flavour

Favourite drink
water

Favourite treat
cheese

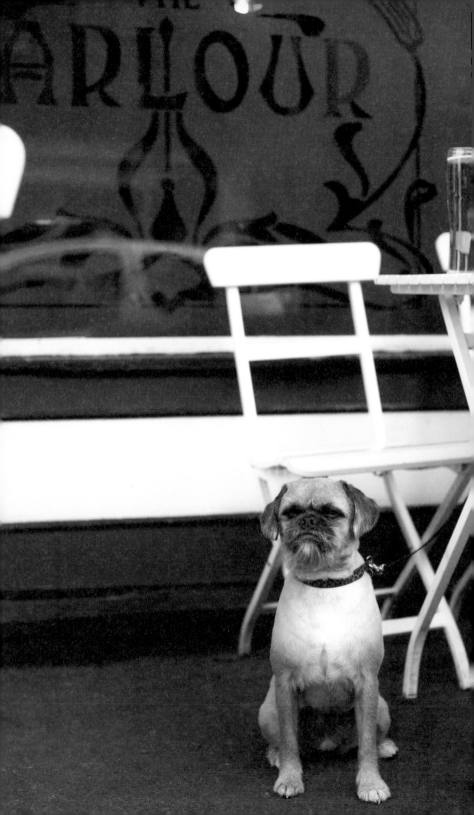

WICKET

THE PARLOUR

Shih Pug

Where do they sleep?
under the duvet

When not in Pub likes to
cause mischief

Favourite things
playing with Ziggy the Parrot

Likes cats or loathes cats?
loves everything

Most dislikes
dogs on TV

Best trick
will dance for food

Favourite place
in between legs on
footstool, watching TV

Favourite toy
bouncy balls

Favourite treat
cat food

Favourite drink
milkshake

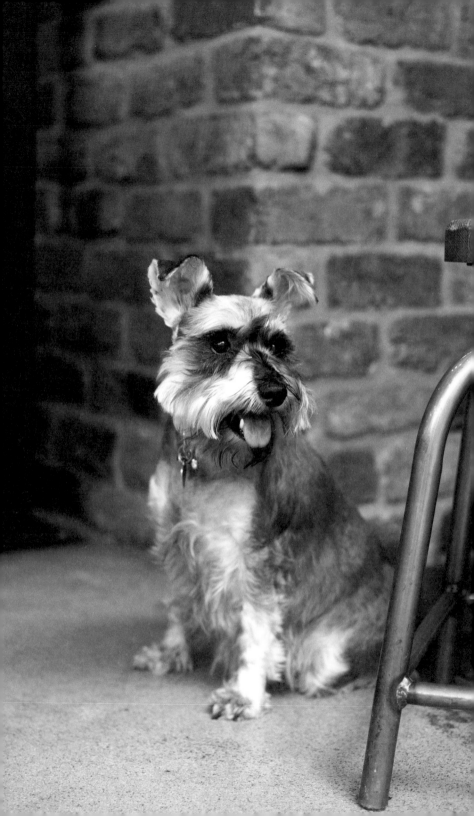

ANGEL

BREWDOG

Miniature Schnauzer

Where do they sleep?
in her basket (with Molly)

When not in Pub likes to
sleep, and go for long walks (runs!)

Favourite things
soft toy fox

Likes cats or loathes cats?
likes cats

Most dislikes
bicycles, prams

Best trick
tongue between teeth, smiling

Favourite place
Rivington Winter Hill

Favourite toy
squeaky ball

Favourite drink
water

Favourite treat
chew bones

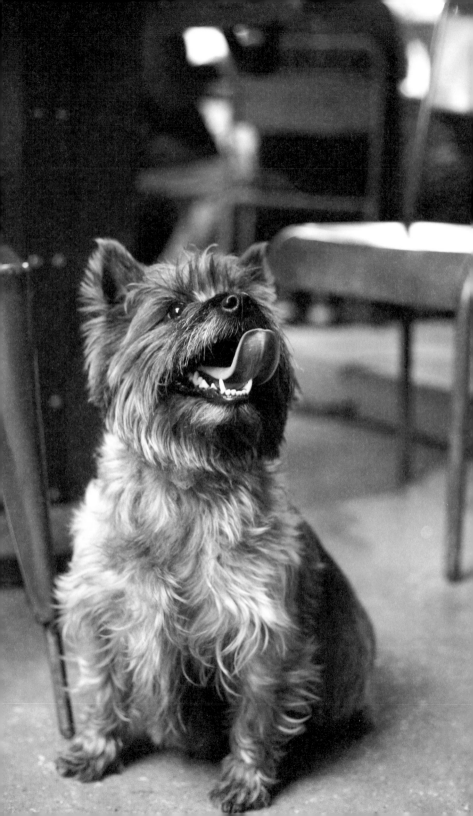

MOLLY

BREWDOG

Cairn Terrier

Where do they sleep?
in her basket (with Angel)

When not in Pub likes to
sleep

Favourite things
balls, soft toys, walkies!

Likes cats or loathes cats?
loathes cats

Most dislikes
bicycles, prams, loud noises

Best trick
rolling over for belly tickles

Favourite place
Rivington Winter Hill

Favourite toy
orange rubber ball

Favourite drink
water

Favourite treat
chew bones

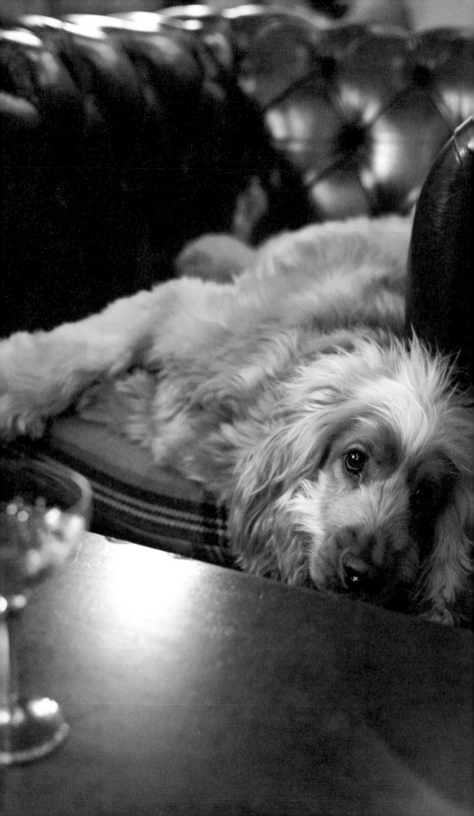

SEAMUS THE WHISKY JAR

Cocker Spaniel

Seamus's Head

Aw Jeezo Ma heid

Ma heid's bouncin
like a Dambuster's bomb

too much ti drink last night man
an av drunk so much
av revertit ti
a Scottish stereotype
whingin in a Scottish accent
aboot oil an independence
a total alky
a total waster

ah might huv an Irish name
but av got a Scottish soul

that's it nay mair
nay mair drink
EVER
am on thi waggon
beginnin now

haud on
ah think am goanti boak

Jeezo

nah
it's awright false alarm

actually
am feelin a lot better now
I can feel the Scottishness
leaving me
I can feel myself
becoming ENGLISH again

becoming
Mancunian again

Crack open a Boddingtons!
I'm totally MAD FOR IT!

SEAMUS

Where do they sleep?
anywhere, but loves the sofa

Favourite things
playing football or
rugby, swimming

Most dislikes
balloons and umbrellas

Favourite place
head in the fridge!

Favourite drink
cold tea, or a nice cider
in the summer!

When not in Pub likes to
get as dirty as physically possible

Likes cats or loathes cats?
he likes them, they don't like him!

Best trick
playing innocent

Favourite toy
bubble machine

Favourite treat
sausages

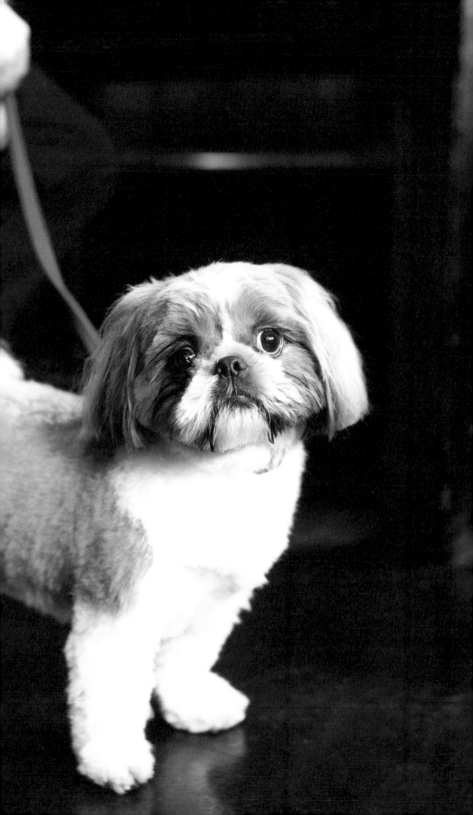

COOPER

DOG & PARTRIDGE

Shih Tzu

Where do they sleep?
anywhere he wants but
he loves his bed too

Favourite things
walkie, car rides, paddling
— the muddier the water the
better, chewing his antler,
sitting on someone's lap

Most dislikes
baths

Favourite place
the park

Favourite drink
water, especially when
paddling in streams

When not in Pub likes to
play with his doggy mates and
watching the world go by from
the window

Likes cats or loathes cats?
likes cats — just wants to be friends

Best trick
his meerkat impression,
balancing on his back legs

Favourite toy
squeaky cow
(he's destroyed 3 so far!)

Favourite treat
sausages

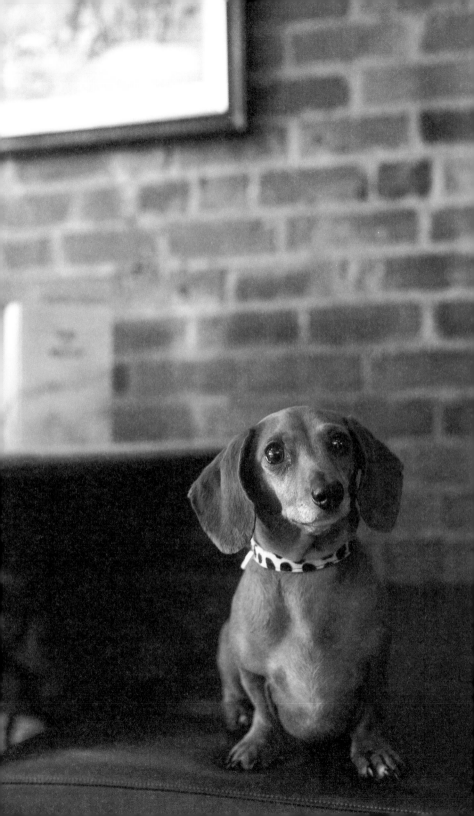

PIXIE

Miniature Dachshund

WINE AND WHALLOP

Where do they sleep?
in her crate

Favourite things
Mum and Dad!

Most dislikes
the rain, wet pavement

Favourite place
on Mum's lap, under a blanket

Favourite drink
goat milk

When not in Pub likes to
hang out on Twitter
(@Pixiethemsd)

Likes cats or loathes cats?
tolerates our cat Poppy,
the chocolate Burmese

Best trick
Doesn't do tricks!

Favourite toy
badger

Favourite treat
cheese

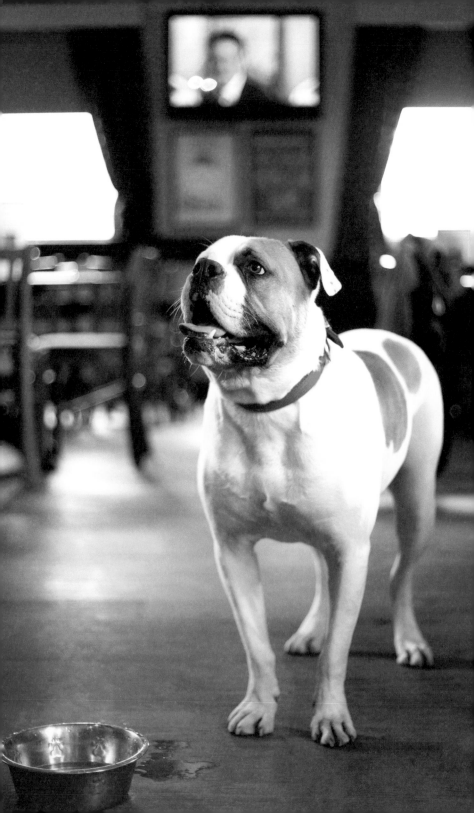

HUGO

American Bulldog

THE BOWLING GREEN

Where do they sleep?
on the landing

Favourite things
food, eating shoes

Most dislikes
going on the lead

Favourite place
on the table

Favourite drink
tea

When not in Pub likes to
slobber on everyone

Likes cats or loathes cats?
hates cats

Best trick
No tricks, just sitting!

Favourite toy
bones

Favourite treat
dog treats

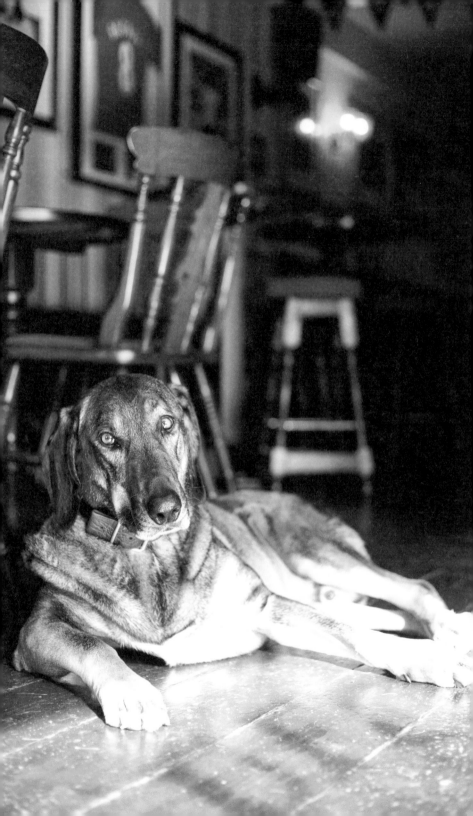

TOMMY

DUFFY'S BAR

Bloodhound x
German Shepherd

Where do they sleep?
in his huge dog bed!

Favourite things
a nice cheese board washed
down with a glass of cold water

Most dislikes
a bath

Favourite place
the meadows

Favourite drink
muddy puddle on the meadows

When not in Pub likes to
work out

Likes cats or loathes cats?
only likes them as he gets bullied
by cat

Best trick
understanding three languages:
Spanish, Catalan, English

Favourite toy
Balls, balls and more balls

Favourite treat
Going to Duffy's as they always
have treats for him behind the bar

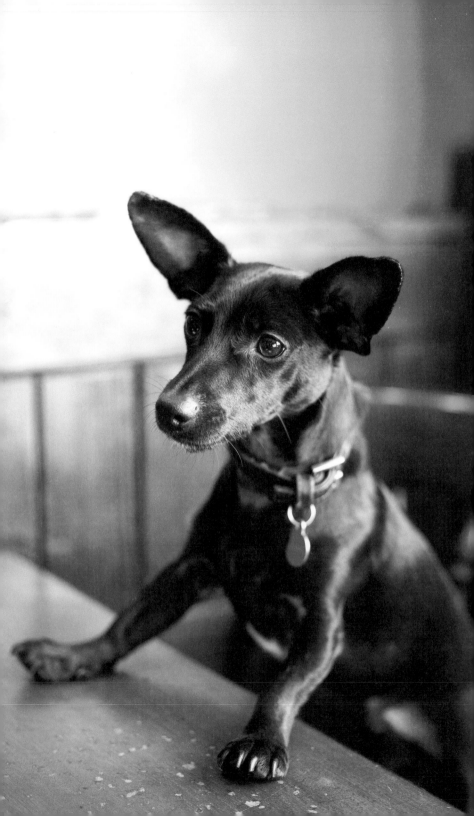

JAKE

DOG & PARTRIDGE

*Jackadach
(Jack Russell x Dachshund)*

Where do they sleep?
under the duvet of the
king-size bed!

Favourite things
food, cuddles, rough and tumble

Most dislikes
mud, rain, bridges

Favourite place
in the sunshine,
in the king-size bed

Favourite drink
beer froth, doggycino

When not in Pub likes to
play ball, destroy toys,
walk by the river Mersey

Likes cats or loathes cats?
intrigued by cats, likes to chase
them (but they are bigger than him!)

Best trick
meerkat impression

Favourite toy
honkey tonk bear

Favourite treat
pig ears, doggy digestives

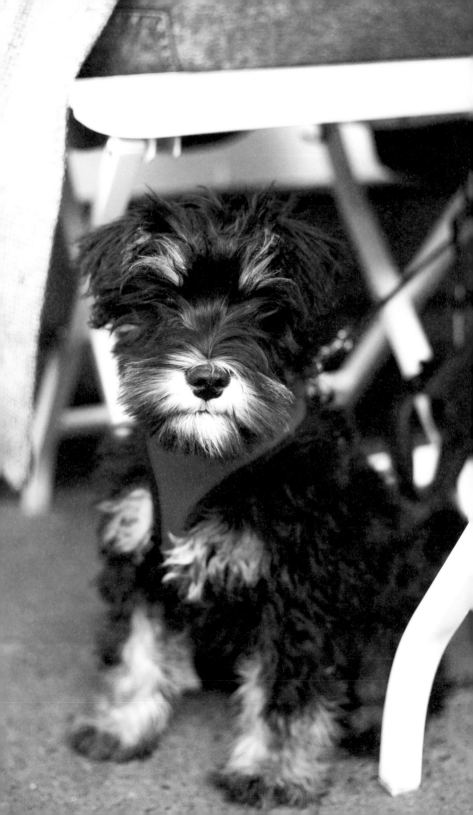

CARSON

THE PARLOUR

Miniature Schnauzer

Where do they sleep?
in his crate with his blanket

Favourite things
Marie the cat, jumping
in bushes and cuddles

Most dislikes
bedtime and being left
at home. And bathtime!

Favourite place
the garden

Favourite drink
cold water

When not in Pub likes to
chase Marie the cat,
snuggle on the couch

Likes cats or loathes cats?
loves them!

Best trick
bunny hopping up stairs and steps

Favourite toy
his burger toy

Favourite treat
chicken

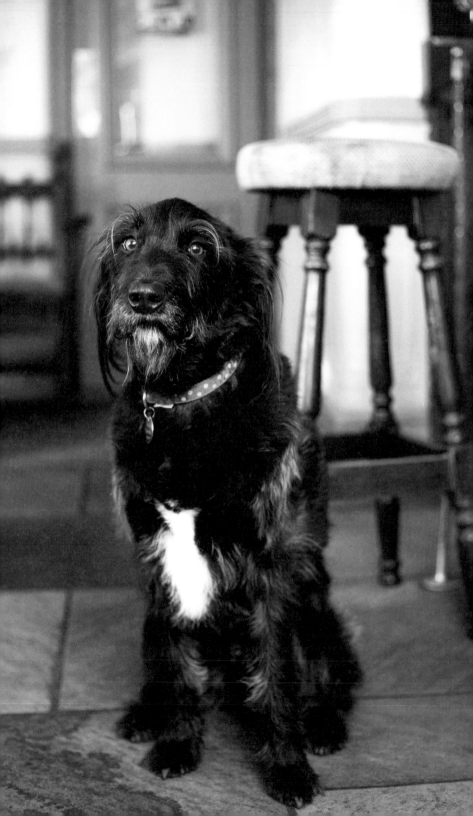

ARCHIE

THE BEECH

Labrador x Collie

Archie's Stare

Look into my eyes.

How do you like my
Thousand Yard Stare?

I've been practicing
for years,
pretending I'm
a veteran from Nam,
or Iraq, or Afghanistan,
or one of the ones
 that's still to come.

I could have been
a badass pooch –
sniffing out the roadside bombs,
ripping the throats
of the Taliban dafties,
kicking the butts of the IS nuts.

Marching along
with my medals and clasps.

I had to stay here instead
and spend my time
listening to Joy Division
and The Smiths.

Slowly becoming depressed,
waiting for a mission.
Getting softer,
as Morrissey squats in the bush,
getting stronger.

I've always got my stare.
They can't take that
away from me.

I love the smell of
crinkle cut chips in the morning.
Smells like...

crinkle cut chips in the morning.

ARCHIE

Where do they sleep?
At the foot of the bed on his own
luxury mattress

Favourite things
chasing squirrels, cats...
chasing anything basically

Most dislikes
getting cleaned

Favourite place
outside

Favourite drink
dirty puddle water

When not in Pub likes to
cause chaos with his
best friend Oscar

Likes cats or loathes cats?
loathes them with a passion

Best trick
disappearing

Favourite toy
squirrels if he could ever catch one

Favourite treat
found chips

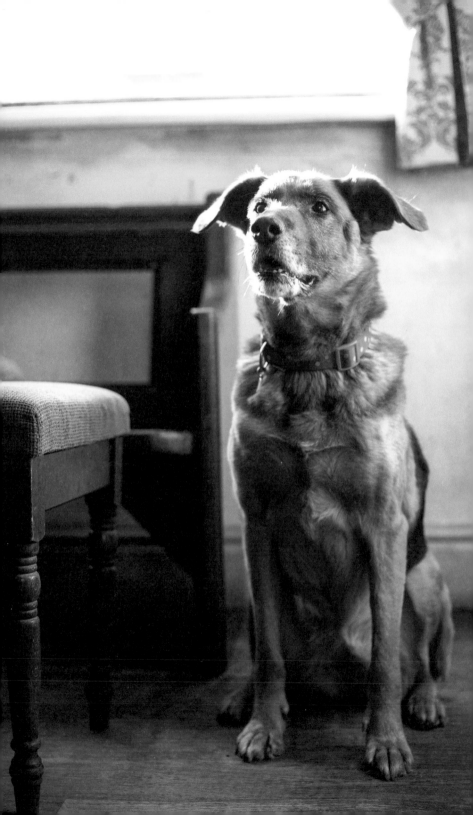

BELLE

THE BEECH

Heinz 57

Where do they sleep?
anywhere she wants to

Favourite things
food – especially blue cheese,
tummy rubs, her best friend
Sammy the Collie

Most dislikes
wet and cold mornings, fireworks,
our other dog getting anything
that she's not

Favourite place
the treat tin at her
"grandparents" house

Favourite drink
dog beer

When not in Pub likes to
walk with her dog pals

Likes cats or loathes cats?
likes to chase them

Best trick
catching balls

Favourite toy
a string of sausages when
she was a puppy

Favourite treat
cheese

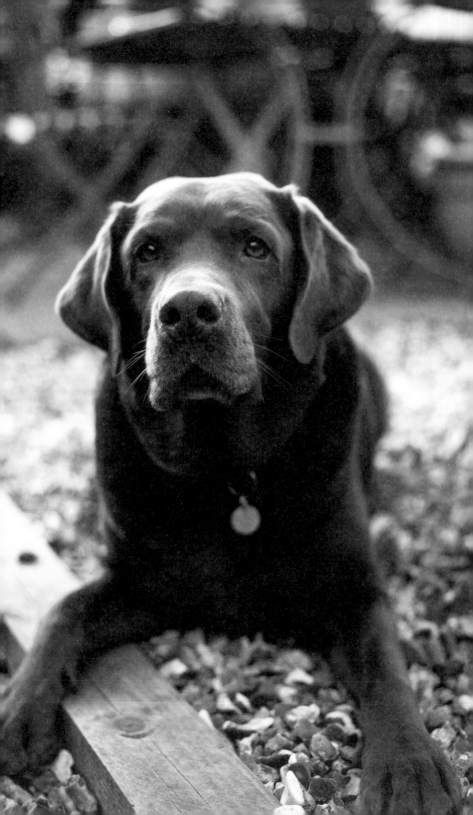

OSCAR

THE BEECH

Labrador

Where do they sleep?
on my bed or cuddler

Favourite things
swimming and rolling in fox poo

Most dislikes
harness and being
disturbed in his bed

Favourite place
Chorlton Water Park and
swimming in the Mersey

Favourite drink
water

When not in Pub likes to
chill / snooze

Likes cats or loathes cats?
chases them

Best trick
roll over

Favourite toy
squeaky plastic chicken

Favourite treat
anything edible... and not

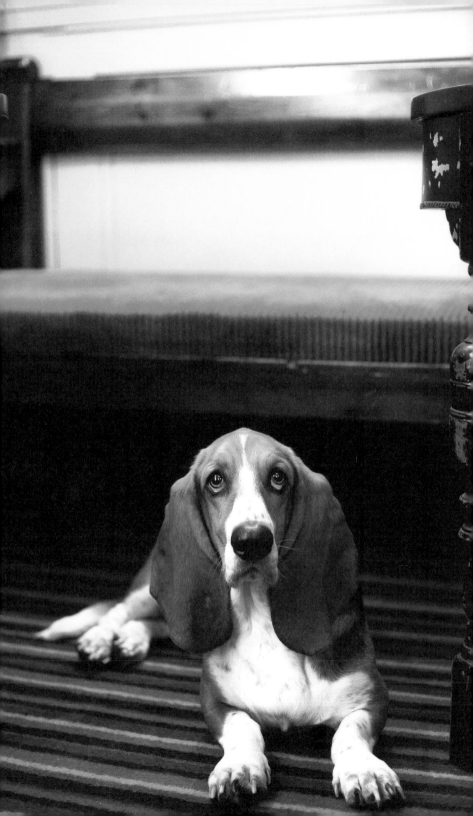

BLUE

THE RAILWAY

Basset Hound

Where do they sleep?
on our bed!

When not in Pub likes to
sniff

Favourite things
A bone from the butchers

Likes cats or loathes cats?
loathes cats

Most dislikes
the hair dryer

Best trick
high five

Favourite place
the park

Favourite toy
her rope toy

Favourite drink
the top of a pint of Guinness!

Favourite treat
a piece of ham

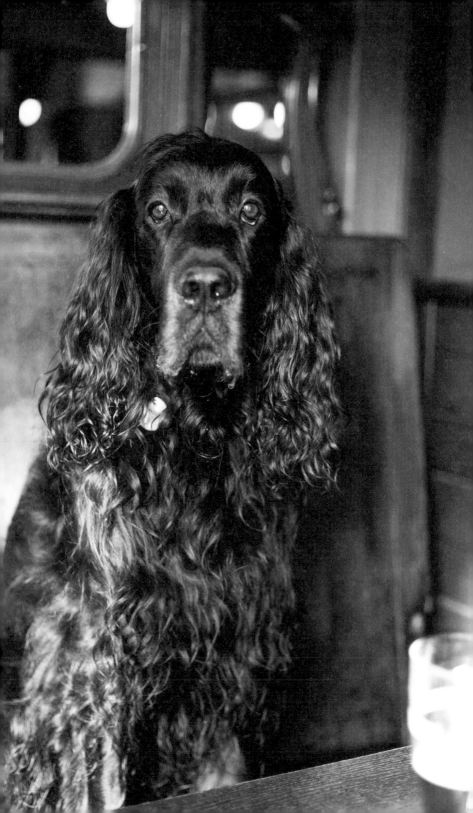

LOUIE

DOG & PARTRIDGE

Gordon Setter

Louie's Court

Here I am in my favourite spot,
setting the world to rights
over a pint and a bone.

Holding court.
The court of Versailles.

Discussing literature
and philosophy,
immigration and existentialism.
The state of the world
of dogs and men.

And, of course, the works
of Camus and Sartre,
the essays of
Simone De Beauvoir.

I'm not too sure about
this 'Pub Doggery' business.
It all seems a bit shallow to me.
Young dogs posing and preening
just because a camera's
in the room.

Taking 'selfies'.
Whatever that is.

How do you like my floppy ears?
They look a bit like
a wig Louis XIV
might have worn,
or possibly Russell Brand's hair
only they
make more sense
and are a lot funnier.

Oh, how I yearn
for the Left Bank,
the dog-dirt lawns of
the Luxembourg Gardens.
The pet cemetery
of Père Lachaise.

Je suis Louie!

Where's my camembert?
I demand my smelly cheese!
I demand my plastic duck!
Je demande mon canard plastique!

LOUIE

Where do they sleep?
anywhere comfortable – spare
room double bed, sofas... and
sneaks into our bed at 5 am

Favourite things
toilet rolls (like an Andrex puppy)
and tissues. Pedal bins, cruising in
cars, long walks by the river or
on the beach

Most dislikes
loud noises, forceful people

Favourite place
park, river, beach and fancy
restaurants when he is in
France. Any comfy bed

Favourite drink
water and tea. Beer on a
Friday at the pub

When not in Pub likes to
walk to the park and travel
(has his own passport, will travel!)

Likes cats or loathes cats?
likes, with a side salad

Best trick
stealing toilet tolls from the
bathroom and emptying bins

Favourite toy
DUCKS. (plastic but loves real
ones too!)

Favourite treat
chicken and smelly cheese
(French Camembert)

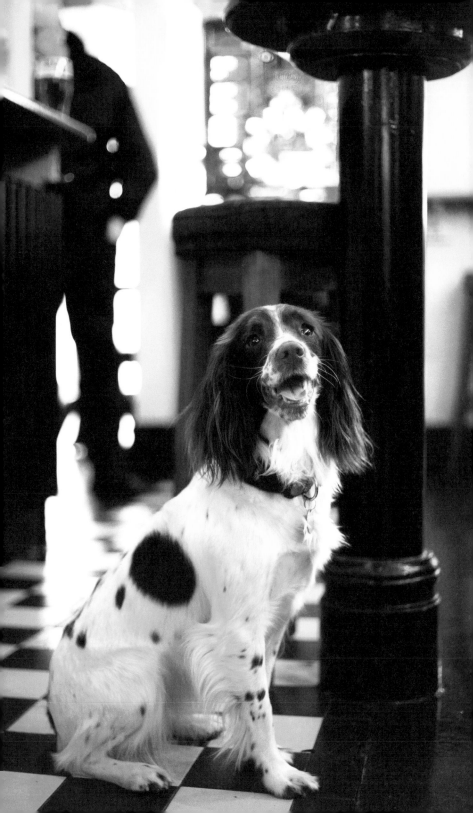

TESS

THE RAILWAY

English Springer Spaniel

Where do they sleep?
on a homemade Liberty print
bed in the kitchen

Favourite things
chasing squirrels in Didsbury Park

Most dislikes
not being able to climb trees
after squirrels in Didsbury Park

Favourite place
stretched out on a sheepskin
rug in front of a log fire

Favourite drink
water (I'm underage for
anything else!)

When not in Pub likes to
walk to the next pub

Likes cats or loathes cats?
I sometimes chase them but
they've got really sharp claws,
haven't they?

Best trick
high five!

Favourite toy
Moo – a wobbly-necked soft
toy cow that cost 50p in the
local charity shop; I've chewed
its tail lovingly

Favourite treat
pear cores

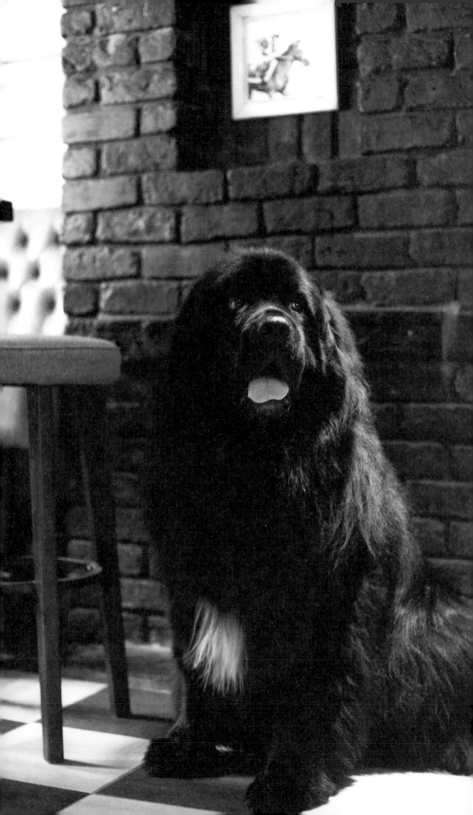

VINNIE

HORSE & JOCKEY

Newfoundland

Vinnie's Plan

Don't worry,
it's not an earthquake.
It's only me
 snoring
 two floors
below.

Snoring so big
to make the walls crack,
make all the High Ones
come tumbling down
in a royal mess
of mattress and springs,
 pyjamas and clocks.

Rescue is in my blood.
My dad before me
and his dad before him.

Saving the Souls
from icy fishing trawler oceans
or snowswept Arctic wastes.

I'm Supercanine.
I can turn my paws to anything,
create my own Tsunami,
my own tectonic trauma.
Pull them out of the rubble
in the nick of time,
be rewarded
with extra cheese and dentastix.

A pat on the head,
a scratch on the chin.

It's a noble plan.
You have to make
your own luck in this world.

It's dog eat dog.

VINNIE

Where do they sleep?
bottom of the stairs or by the front
door, always guarding the family

Favourite things
sleep, human food, sleep,
cold weather and sleep

Most dislikes
fireworks and being left alone

Favourite place
wherever the family is

Favourite drink
cold water, straight
from the garden tap

When not in Pub likes to
sleep!

Likes cats or loathes cats?
likes! Something else to play
with, although none ever do

Best trick
snoring loud enough you can
hear it two floors above

Favourite toy
tiny dogs or human-brother-Matt
– loves to play "chase" and wrestle

Favourite treat
cheese, dentastick and
being fussed over

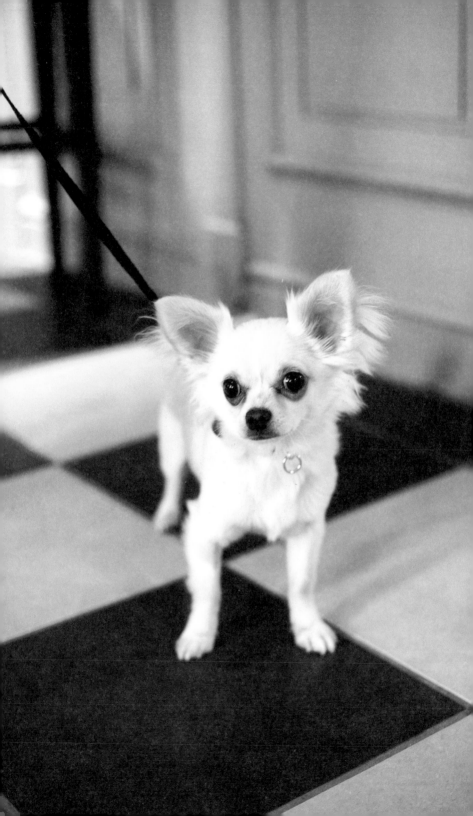

JOCK

Long-haired Chihuahua

HORSE & JOCKEY

Where do they sleep?
kitchen, in a crate

Favourite things
rubber chicken, anything
squeaky, socks

Most dislikes
beards, hats, big dogs

Favourite place
on the sofa

Favourite drink
water

When not in Pub likes to
go for walks around
Charlton Water Park

Likes cats or loathes cats?
loathes

Best trick
meerkat

Favourite toy
rubber chicken

Favourite treat
ham

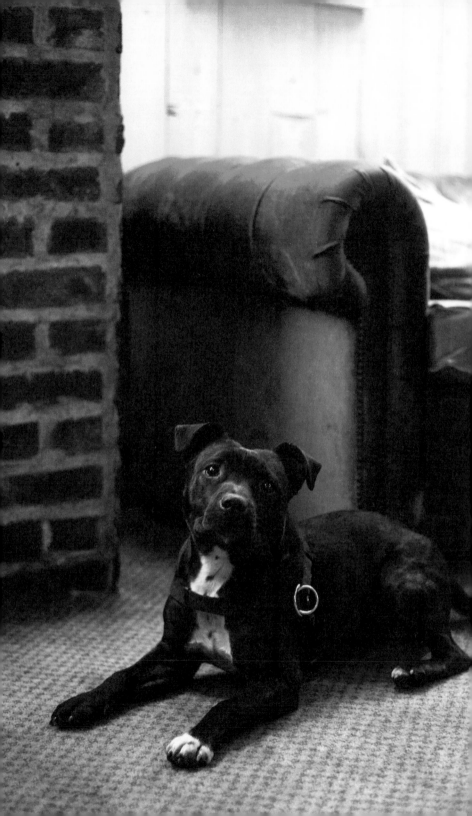

PEARL

Staffordshire Bull Terrier

HORSE & JOCKEY

Where do they sleep?
in her basket

Favourite things
footballs, any food,
beagles called Milo!

Most dislikes
going on the lead

Favourite place
chasing the ball on the Mersey
/ under my feet while I cook!

Favourite drink
water on the rocks

When not in Pub likes to
sleep on the radiator like a cat

Likes cats or loathes cats?
they won't let her get near enough
to find out! (but to be fair she's a
scaredy cat)

Best trick
high five!

Favourite toy
Ted the Teddy bear

Favourite treat
sausages

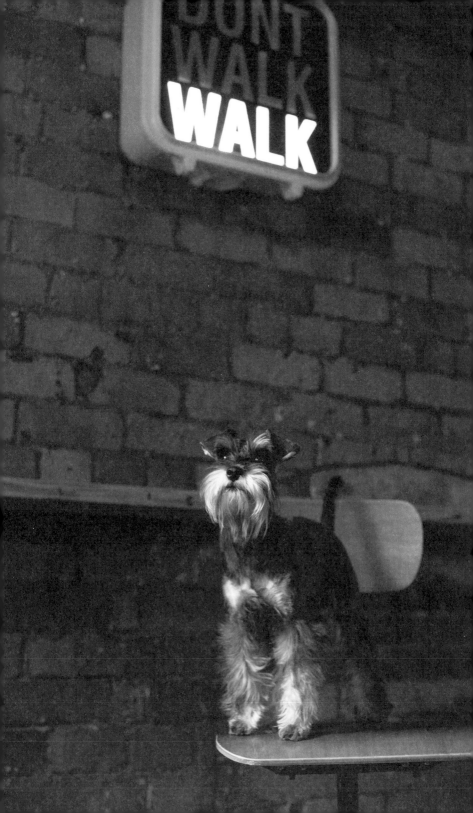

LOLLI

Miniature Schnauzer

KOSMONAUT

Where do they sleep?
in her cosy crate in the utility room

Favourite things
leaves and serviettes

Most dislikes
the ironing board – runs and hides

Favourite place
on the lap of someone willing to
stroke her belly

Favourite drink
water, preferably in puddles

When not in Pub likes to
go for walks in the park, making
friends with dogs twice her size

Likes cats or loathes cats?
not met any yet, but she's friends
with everyone and everything so
I'm sure she'll like them!

Best trick
kisses!

Favourite toy
Mr. Z (squeaky zebra)

Favourite treat
Nam Tea – infused dog treats

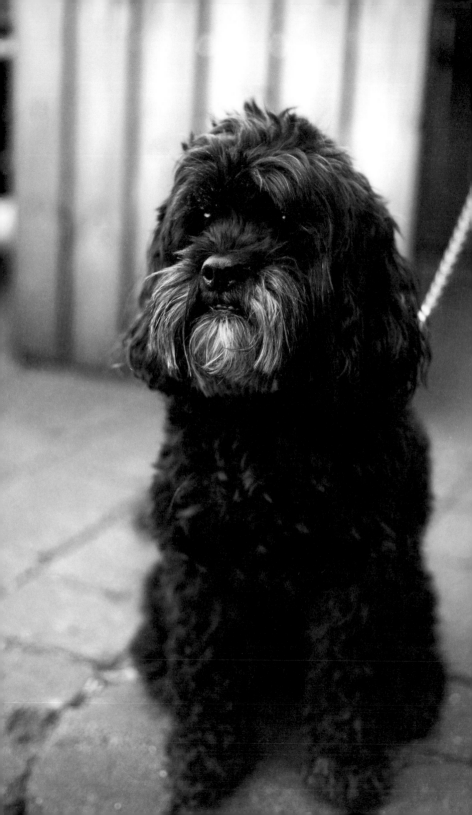

POPPY

THE LEAD STATION

Cockerpoo

Where do they sleep?
in between me and my husband!!
Naughty

Favourite things
squeaky balls and cheese...

Most dislikes
morning tablets...even
hidden in cheese!!

Favourite place
spooning me in bed, head
on pillow, under the duvet

Favourite drink
leftover cereal milk

When not in Pub likes to
sunbathe in the garden

Likes cats or loathes cats?
loathes cats but is terrified of
them at the same time. All bravado,
if the cat retaliates, Poppy legs it

Best trick
wooing whilst doing a
handstand. Very gifted

Favourite toy
big cuddly Winnie the
Pooh teddy bear

Favourite treat
loves a good challenging bone

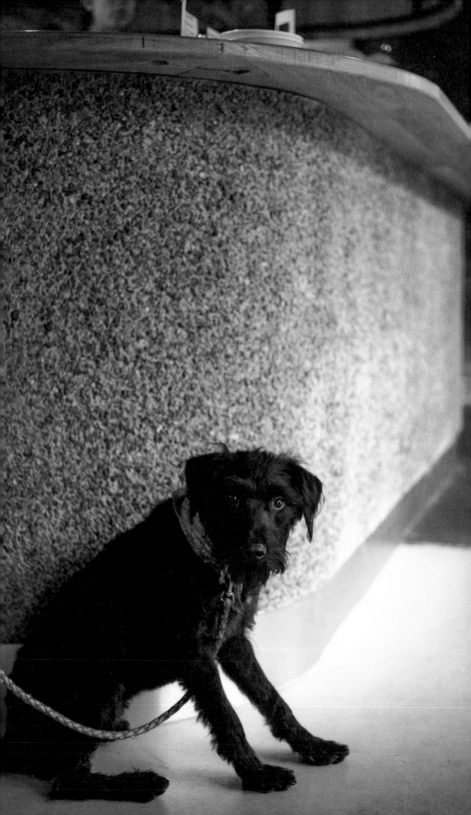

RUFUS

COMMON

Mixed

Where do they sleep?
next to our bed

Favourite things
balls, walkies, chasing geese,
learning tricks

Most dislikes
baths, when mummy doesn't
share her chocolate, birds

Favourite place
the beach in Cornwall

Favourite drink
milk (naughty!)

When not in Pub likes to
chase balls, do Doga (yoga for dogs)
on the carpet, race Dad, drive in the
car with the roof down

Likes cats or loathes cats?
loathes

Best trick
high five

Favourite toy
ball and rubber hamburger

Favourite treat
hotdogs

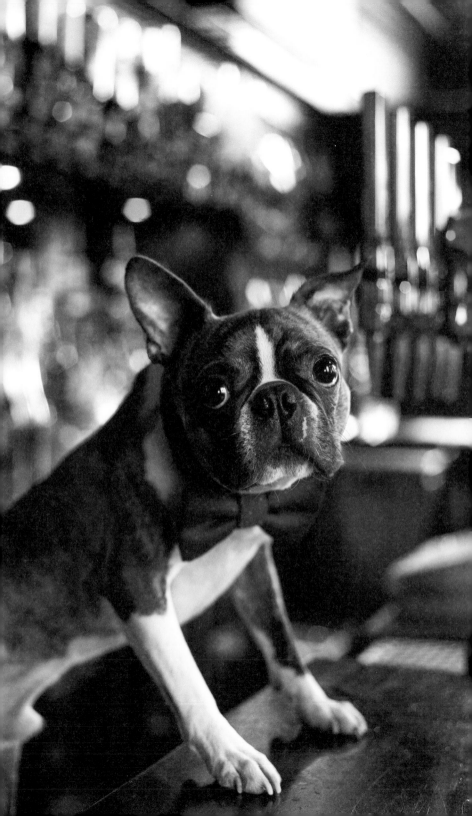

FRANKLIN

CROWN & KETTLE

Boston Terrier

Where do they sleep?
in his own little dog house,
next to my bed

Favourite things
meeting other dogs,
the seaside, lots of food

Most dislikes
spicy food

Favourite place
the seaside

Favourite drink
water

When not in Pub likes to
walk in the park or by the canals

Likes cats or loathes cats?
likes cats – has a 'cousin'
named Walter

Best trick
hand shake / high five, roll over

Favourite toy
his Kong snack toy

Favourite treat
peanut butter (organic)

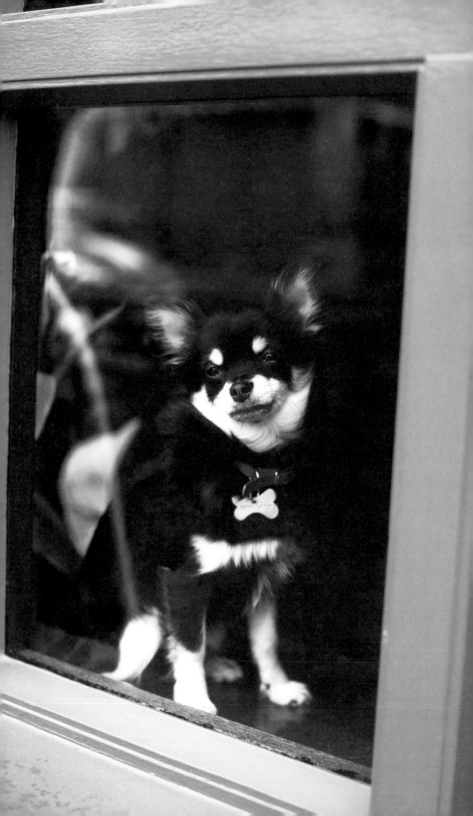

VINCENT CASK

Pomchi

Where do they sleep?
in bed between his Mum
and Dad

Favourite things
human food, walks

Most dislikes
being squeezed (cuddled)

Favourite place
the back garden where he can
see his neighbour Bobby (a Westie)

Favourite drink
milk from cereal bowl

When not in Pub likes to
play with his football
which is bigger than him

Likes cats or loathes cats?
loves cats!

Best trick
making friends / fans
wherever he goes

Favourite toy
a cuddly dog-fish

Favourite treat
Twigletts

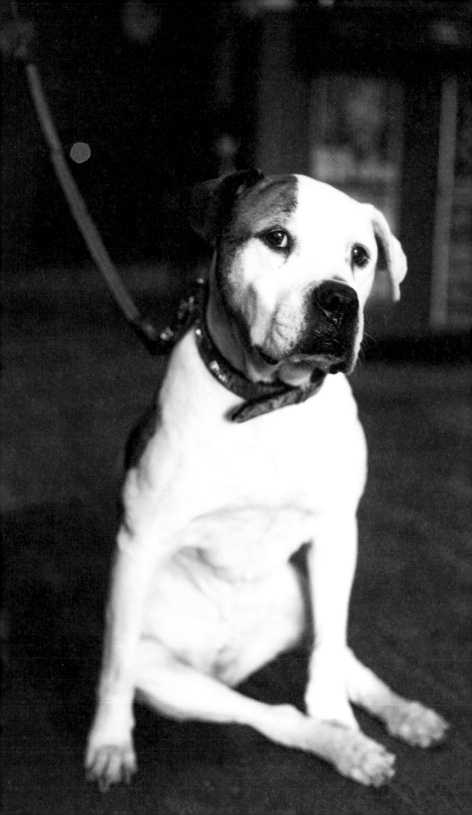

KIA

CASK

American Bulldog

Where do they sleep?
bottom of the bed

Favourite things
food, walking and going to the pub

Most dislikes
nothing

Favourite place
Cask

Favourite drink
milk

When not in Pub likes to
go for long walks

Likes cats or loathes cats?
likes cats

Best trick
sad eyes

Favourite toy
ball

Favourite treat
beef biltong

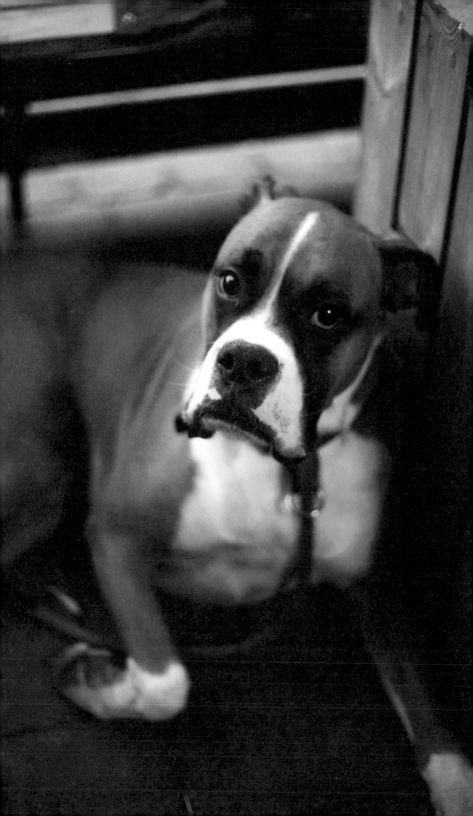

COOPER

THE LEAD STATION

Boxer

Where do they sleep?
he sleeps in his own bed
in our bedroom

Favourite things
his two friends (dogs)
Oscar and Alfie

Most dislikes
crowds

Favourite place
the beach

Favourite drink
water

When not in Pub likes to
play and walk

Likes cats or loathes cats?
likes to chase cats for the fun of it
but runs away barking if he catches
up with one. Although we had an
old cat and he never bothered it

Best trick
looking cute and creeping

Favourite toy
an old, stuffed, floppy
green crocodile

Favourite treat
cheese

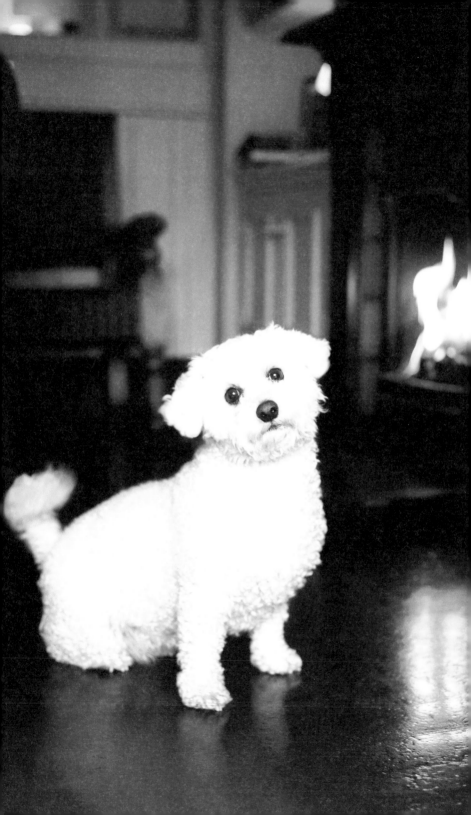

FIZZIE

THE RAILWAY

Bichon Frisé

Where do they sleep?
my bed

Favourite things
being loved

Most dislikes
she's so happy it's hard to say

Favourite place
Charlton Water Park

Favourite drink
milk with a bit of sugar (last of
my cereal bowl in the morning)

When not in Pub likes to
Sit on her side of the sofa
and watch the world go by

Likes cats or loathes cats?
obsessed with cats

Best trick
jump up and kisses

Favourite toy
she's fickle with toys

Favourite treat
chicken chew strip
(Aldi's version is her favourite)

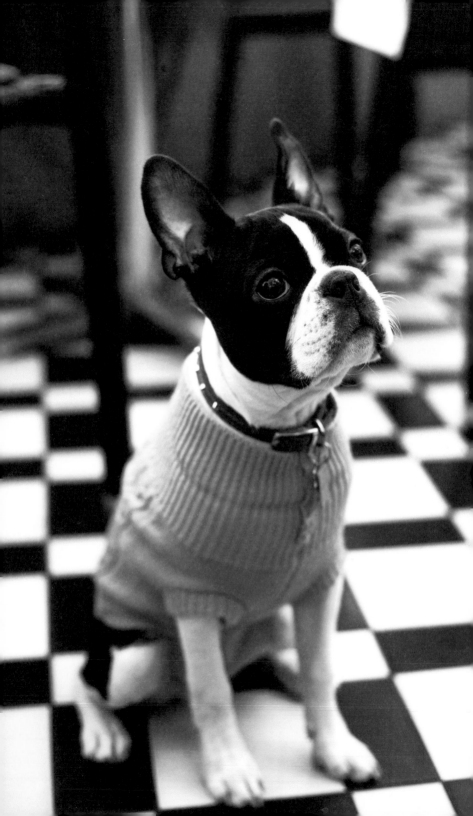

OTIS

Boston Terrier

ALBERT'S SHED

Where do they sleep?
owner's bed

When not in Pub likes to
sleep

Favourite things
treats and toys

Likes cats or loathes cats?
loves them

Most dislikes
being ignored

Best trick
high five and walking on two legs

Favourite place
bed

Favourite toy
sausages on a string

Favourite drink
water

Favourite treat
doggie milk chocolate drops

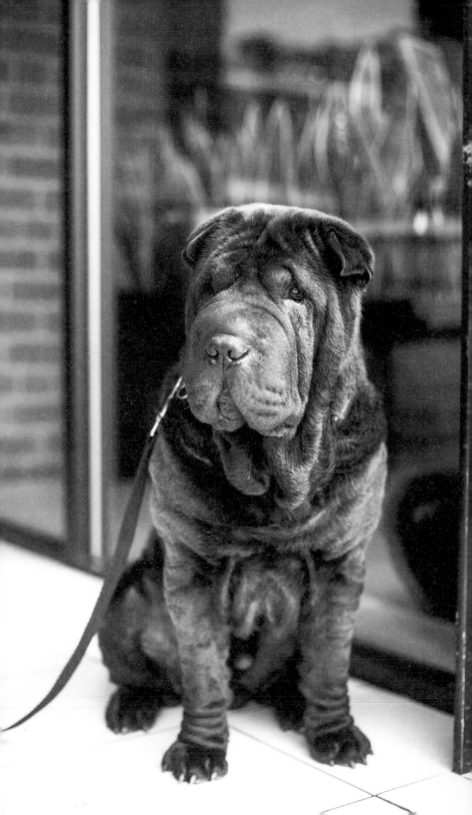

BRUCE

DUKES 92

Shar Pei

Where do they sleep?
in the living room

When not in Pub likes to
chase birds

Favourite things
my other dog and football

Likes cats or loathes cats?
not sure

Most dislikes
water (rain, bath...)

Best trick
look cute

Favourite place
in the park

Favourite toy
bone

Favourite drink
water

Favourite treat
chocy treats

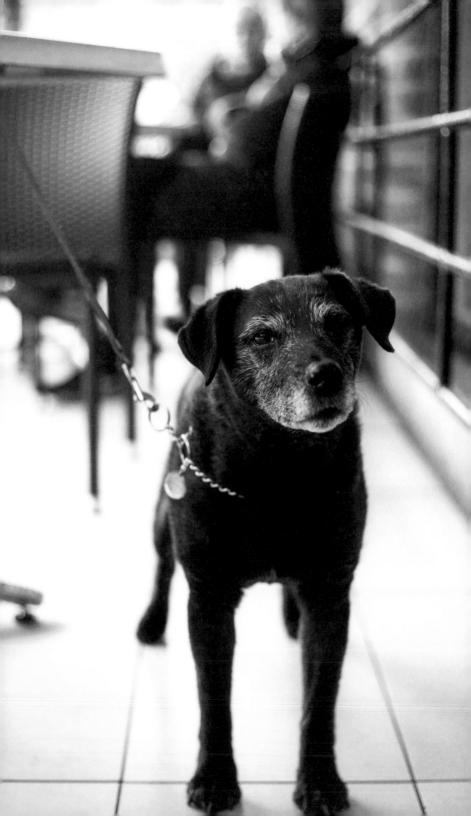

JOSIE

Patterdale tTrrier

DUKES 92

Josie's Life

A photograph?

You want to take
a photograph of me?

Sorry, you must have
the wrong dog.

I'm not special.
Not special at all.

I can't compete
with tightrope walking TV stars,
Boston Terriers wearing bowties,
Cockapoos that can pee
while doing a handstand.

I can't smile
while hustling for treats.

Sorry.

All I can do
is be old and wise
with sweet, sad eyes.

Know where I've been
and know where I'm going.

All I can do
is stand here, and wait.

If that's all you need
then please feel free.

JOSIE

Where do they sleep?
kitchen

When not in Pub likes to
chase my other dogs

Favourite things
squeaky toys

Likes cats or loathes cats?
loathes cats

Most dislikes
being shouted at

Best trick
sit and beg

Favourite place
in front of the fire

Favourite toy
any squeaky toy

Favourite drink
water

Favourite treat
chocolate

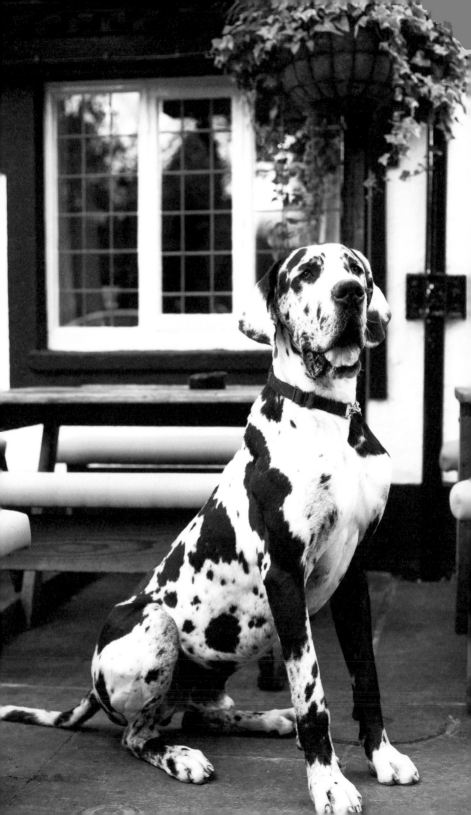

PADDY

HORSE & JOCKEY

Great Dane

Where do they sleep?
next to her food

When not in Pub likes to
run and run and run

Favourite things
her pack

Likes cats or loathes cats?
loathes!

Most dislikes
cars, loud noises,
walking on the lead

Best trick
getting slobber on the ceiling
and letting herself in her food bin

Favourite place
on your lap

Favourite toy
her rope

Favourite drink
dirty puddles

Favourite treat
owner's dinner if she
gets there quick enough,
particularly steak mince

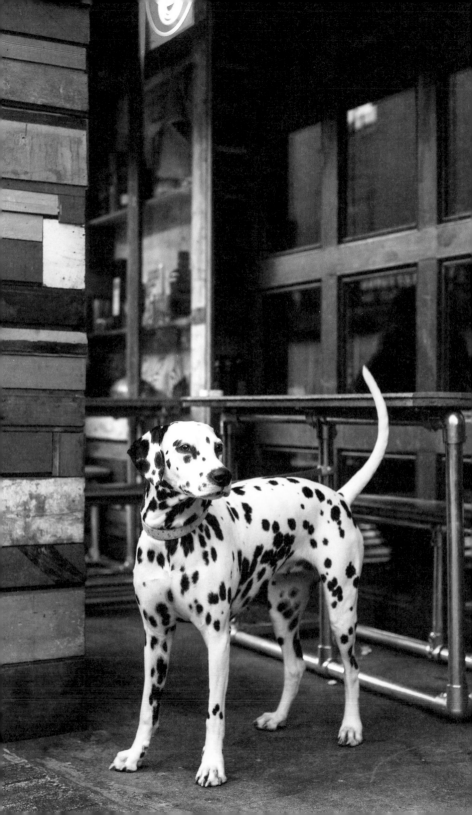

WILLOW

CANE & GRAIN

Dalmatian

Where do they sleep?
taking up most of her
owners king size bed

Favourite things
jumping in big muddy puddles and
late night cuddles watching TV

Most dislikes
the smoke alarm and
having a shower

Favourite place
playing at the dog park
with her friends

Favourite drink
cups of tea

When not in Pub likes to
go on adventures on the train

Likes cats or loathes cats?
loves cats however that's not
normally reciprocated

Best trick
opening the front door

Favourite toy
her owner's newest pair of shoes

Favourite treat
a piece of toast

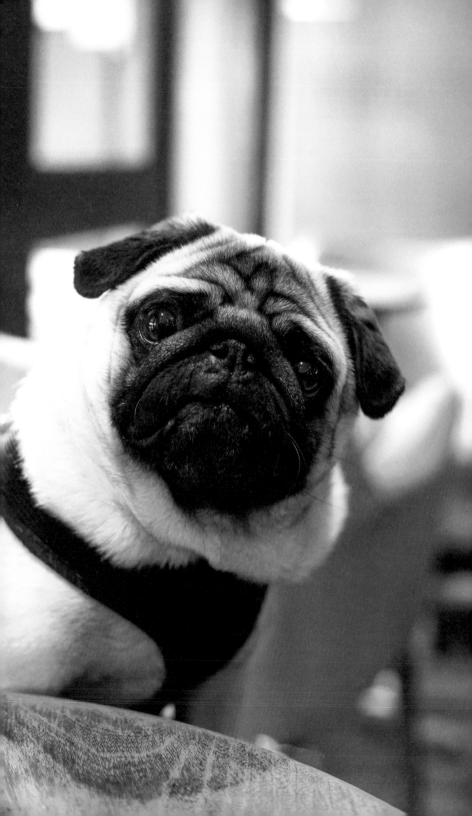

RILEY

ELECTRIK

Pug

Where do they sleep?
in his basket

Favourite things
sausages, barking at the TV,
chasing his curly tail, bathtime

Most dislikes
other dogs, big walks

Favourite place
grandma's, mum and dad's bed

Favourite drink
water, tiny bit of daddy's beer

When not in Pub likes to
sleep, snore, snot, rocket,
sunbath, EAT EVERYTHING
AND ANYTHING

Likes cats or loathes cats?
luuuuvs cats (especially
his buddy Leo)

Best trick
trumping unexpectedly when
barking at the TV. "Toot, toot"

Favourite toy
socks

Favourite treat
weekly weekend sausage

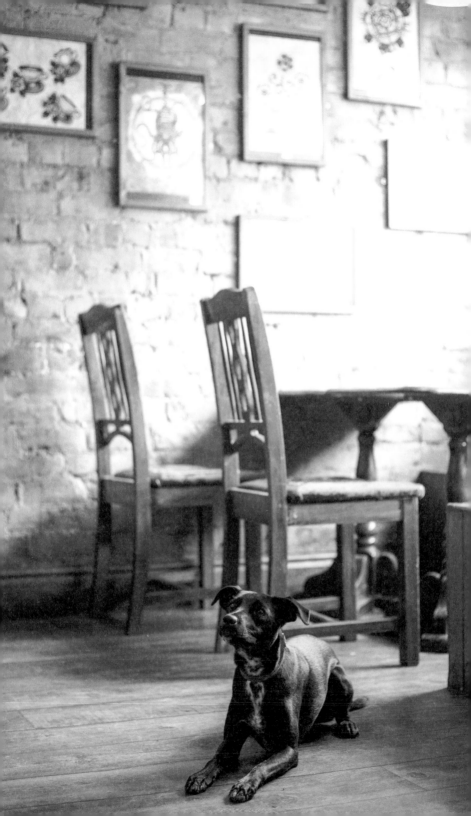

CAPTAIN DULCIMER

Labrador cross

Where do they sleep?
in her crate

Favourite things
other dogs, destroying toys,
running in circles, sleeping

Most dislikes
being left alone

Favourite place
Longford Park, Chorlton Water Park

Favourite drink
beer

When not in Pub likes to
sleep

Likes cats or loathes cats?
likes chasing them

Best trick
going to bed on demand

Favourite toy
an orange ball that she's incapable
of destroying

Favourite treat
Dentastix

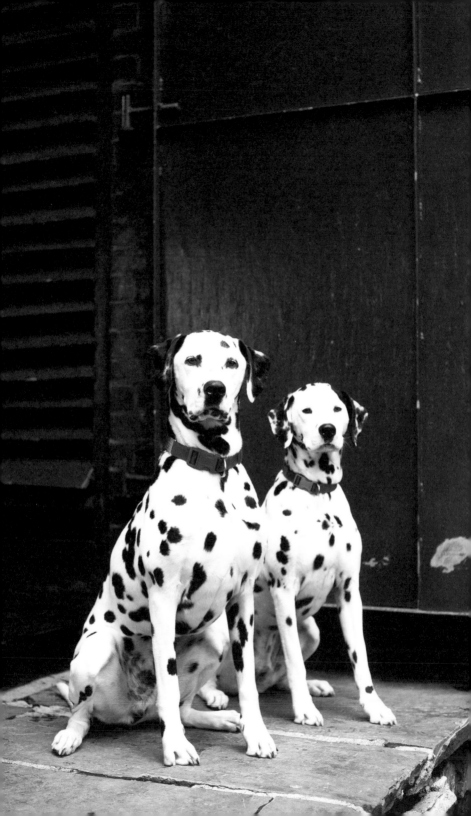

MUFFIN & MALACHI

ATLAS BAR

Dalmatians

Where do they sleep?
on the settee, as soon as anyone
gets off it

Favourite things
eating, running, and more running!

Most dislikes
being washed after being in mud,
and not getting on the settee first

Favourite place
any field, especially where
they can play hide and seek
with our boys

Favourite drink
water

When not in Pub likes to
run and eat and play with each
other. Muffin likes to snuggle,
Malachi likes to watch TV

Likes cats or loathes cats?
likes cats

Best trick
Muffin crawls under the dining
room table to go round our
older dog and is also very good
at opening gates with her feet!
Malachi is good at persuading
children to get him extra treats!

Favourite toy
Muffin loves his tennis ball,
Malachi has his stuffed monkey

Favourite treat
cheese

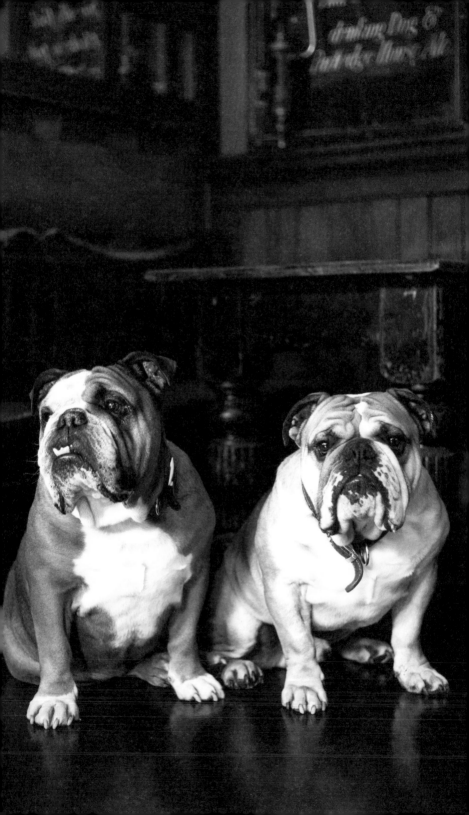

BRUCE & BUSTER

DOG & PARTRIDGE

British Bulldogs

Where do they sleep?
Anywhere!

Favourite things
food, footballs, squeaky
toys and visitors

Most dislikes
Bruce hates the hoover,
Buster hates walks

Favourite place
sofa, with mum and dad

Favourite drink
beer, tea and water

When not in Pub likes to
sleep, eat, repeat

Likes cats or loathes cats?
GRRRRRR!

Best trick
psychic ability to sniff out treats

Favourite toy
footballs and squeaky toys

Favourite treat
ham, cheese, chicken,
biscuits...anything?

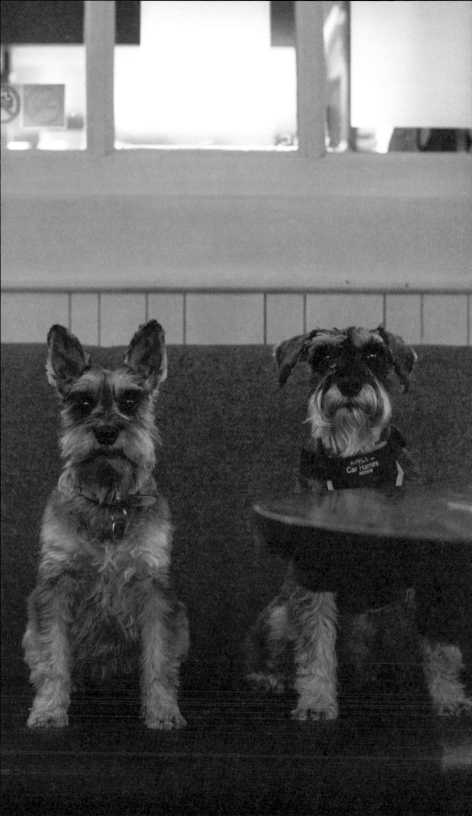

PENNY & DAISY

Miniature Schnauzers

THE RAILWAY

Penny and Daisy's Law

We're Penny and Daisy,
the nicotine police.
The Schnauzer CID.

The Scott and Bailey
of the canine world.

Bad cop.
Even badder cop.

Do you see that sign
in the window behind us?

It means NO SMOKING.

We're watching you.
We're watching for
anything that looks like
a fag, a cigar,
a virtual drag.

A cloud of electronic smoke.

As far as we're concerned
it also means
No inhaling No exhaling
No breathing No dreaming
No reading No farting
No brightly coloured underwear
No shoes No socks
No fun No sun
No snow No fog
No cats No dogs
No thoughts No smiles
No tears No

go back a bit.

Did we say No Dogs?

Right, we're nicked.
Strangeways here we come!

It's a fair cop guv,
but society's to blame.

PENNY & DAISY

Where do they sleep?
beds, on landing

When not in Pub likes to
sleep, walk, play, bark!

Favourite things
treats, tennis balls, retrieval

Likes cats or loathes cats?
chase cats

Most dislikes
bath

Best trick
roll over

Favourite place
parks / walking

Favourite toy
ball on a rope called "ropey ball"

Favourite drink
water, dog beers

Favourite treat
anything!

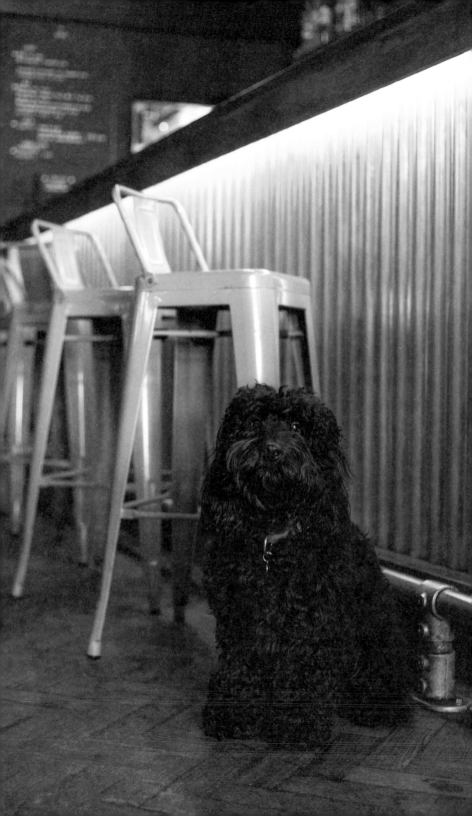

MAC

Cockapoo

DUSK TIL PAWN

Where do they sleep?
anywhere that's cool — bathroom tiles, hallway

Favourite things
coconut oil, sardines, tuna and crabsticks

Most dislikes
sharing crabsticks with Rebecca

Favourite place
Dusk till Pawn!

Favourite drink
water on rocks

When not in Pub likes to
people watch from window at home or chase squirrels in park

Likes cats or loathes cats?
likes to chase them, never caught one to date!

Best trick
bellyflop

Favourite toy
Alex the lion

Favourite treat
veal sausages

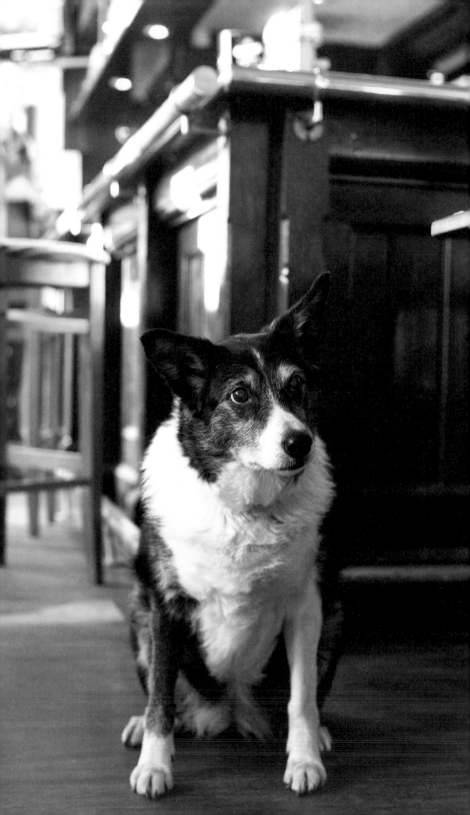

MARLEY

THE BOWLING GREEN

Border Collie

Where do they sleep?
with mum in bed

When not in Pub likes to
lie next to mum on sofa

Favourite things
walks, chocolate drops, toys

Likes cats or loathes cats?
loathes

Most dislikes
other dogs

Best trick
begging

Favourite place
Chorlton Water Park

Favourite toy
baby bunny soft toy

Favourite drink
water

Favourite treat
chocolate drops

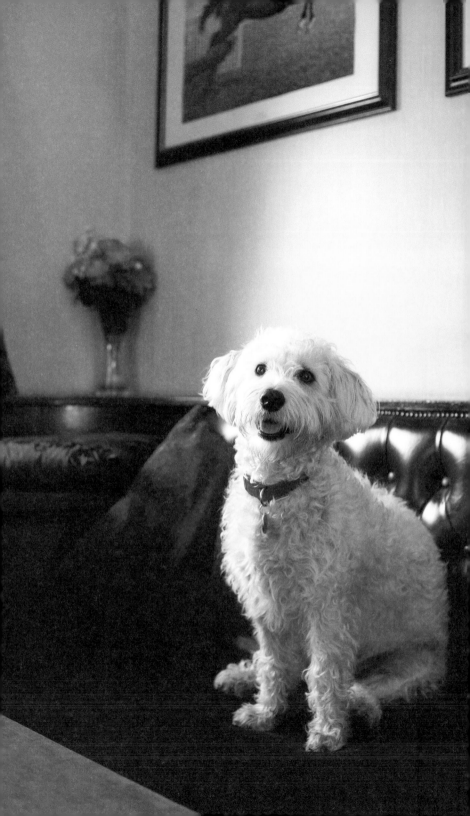

PERO

Labradoodle

THE BOWLING GREEN

Where do they sleep?
in my bed

Favourite things
food, chasing and being chased

Most dislikes
motorbikes and being made to sit still

Favourite place
under the table, chewing
someone's feet

Favourite drink
puddles

When not in Pub likes to
run around and yap at
inanimate objects

Likes cats or loathes cats?
loathes

Best trick
speaks Welsh

Favourite toy
tennis ball (only when in motion)

Favourite treat
jerky and pig ears

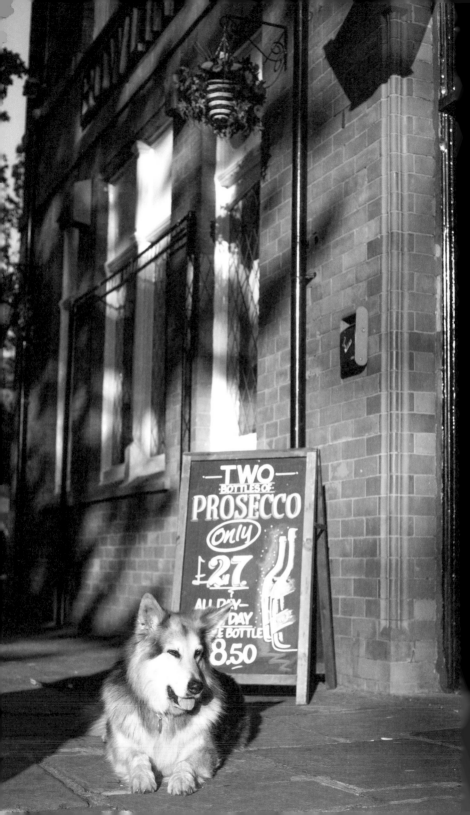

STAR

THE BOWLING GREEN

Colsatian

Where do they sleep?
memory foam mattress
in my room

Favourite things
hanging her head out of
the car window

Most dislikes
ear cleaning

Favourite place
Formby Beach

Favourite drink
stout

When not in Pub likes to
nap

Likes cats or loathes cats?
not even bothered

Best trick
"what's the time Mr Wolf?"

Favourite toy
jolly ball

Favourite treat
CURRY

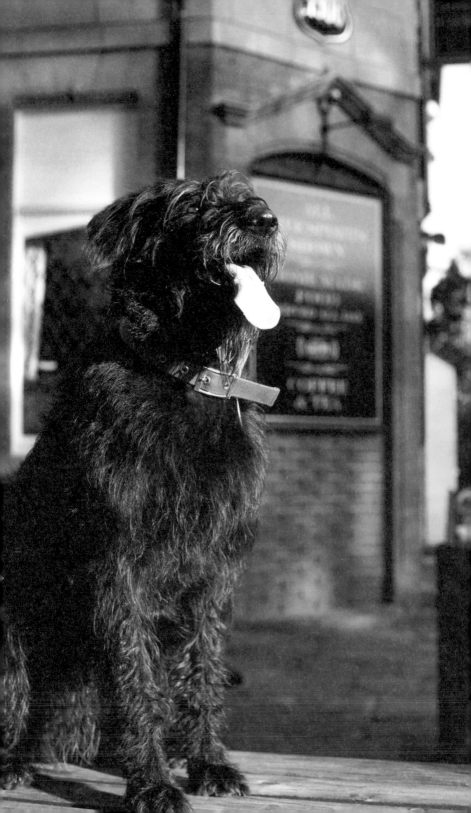

WILLOW

THE BOWLING GREEN

Labradoodle x Lurcher

Where do they sleep?
memory foam mattress
at the bottom of my bed

Favourite things
hogging the ball

Most dislikes
when another dog gets the ball first

Favourite place
chasing after balls

Favourite drink
chocolate milkshake

When not in Pub likes to
squirrel for squirrels

Likes cats or loathes cats?
fascinated with cats

Best trick
catching Frisbees and diving

Favourite toy
Kong&bounce

Favourite treat
pickled onion Monster Munch

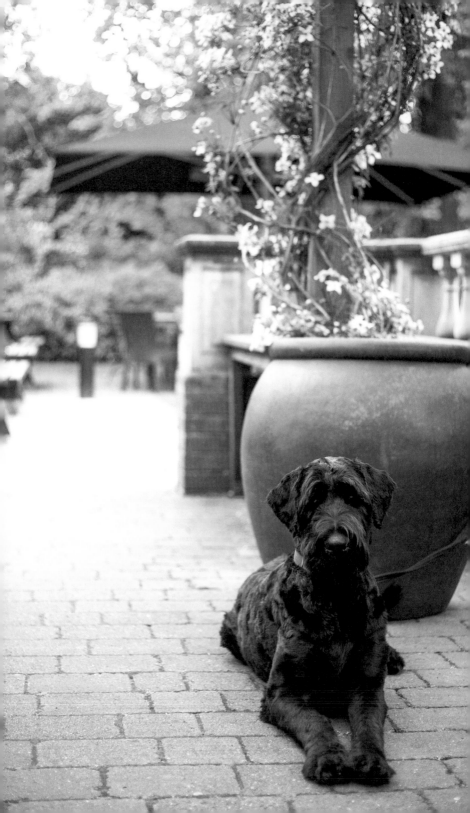

GEORGIE

THE WOODSTOCK ARMS

Giant Schnauzer

Where do they sleep?
anywhere near her owners,
anywhere she shouldn't be!

Favourite things
playing with other dogs, chasing
geese, rolling in smelly things

Most dislikes
being told no

Favourite place
doggy day care with
all the other dogs

Favourite drink
water, and lots of it

When not in Pub likes to
go for big long walks off
lead and chase geese

Likes cats or loathes cats?
likes cats a bit too much

Best trick
stick 'em up / bang!

Favourite toy
anything you can play
tug of war with

Favourite treat
cheese and food off your
plate if she can get it!

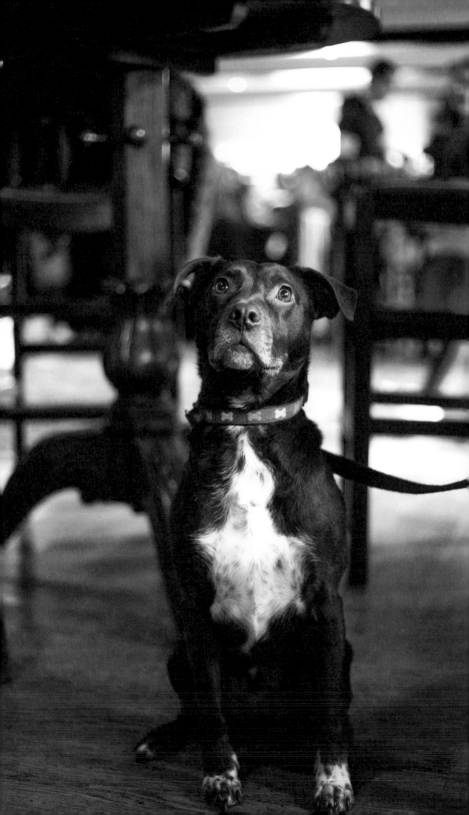

OSCAR

THE WHARF

Staffy x Labrador

Where do they sleep?
on the sofa

When not in Pub likes to
chase balls

Favourite things
the ball!

Likes cats or loathes cats?
lives with 2 cat brothers!

Most dislikes
the postman

Best trick
mind control of owner

Favourite place
Crosby beach

Favourite toy
a ball

Favourite drink
water...

Favourite treat
stolen cat food

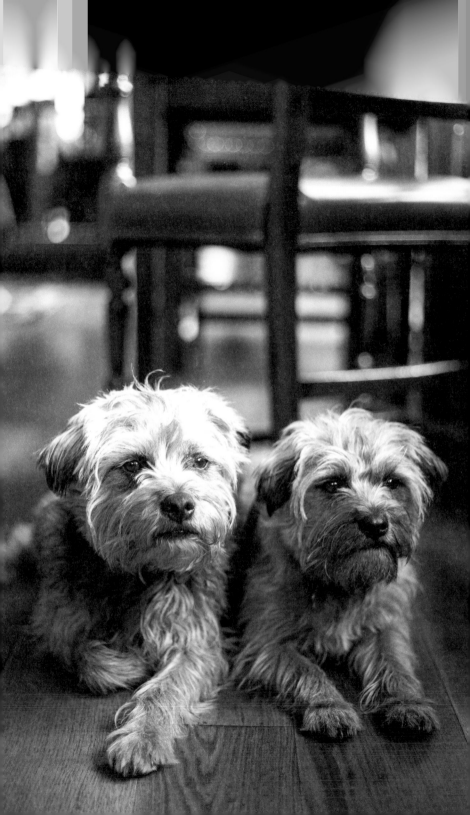

HOLLY & BADGER

THE WHARF

Border Terriers

Where do they sleep?
on their mum and dad's bed, or
in their baskets, if they
are being mean

Favourite things
beaches, chasing rabbits

Most dislikes
Badger dislikes canals after falling
in one and having to be rescued,
when he was a puppy. Holly hates
being ignored!

Favourite place
Delamere Forest

Favourite drink
Holly loves beer, Badger tea

When not in Pub likes to
go running with daddy

Likes cats or loathes cats?
love cats, but cats don't love
them. They live with Kipper,
Honey and Poppy the cats

Best trick
looking sad to get food

Favourite toy
Holly loves her rubber duck,
and Badger has a broken football

Favourite treat
chips

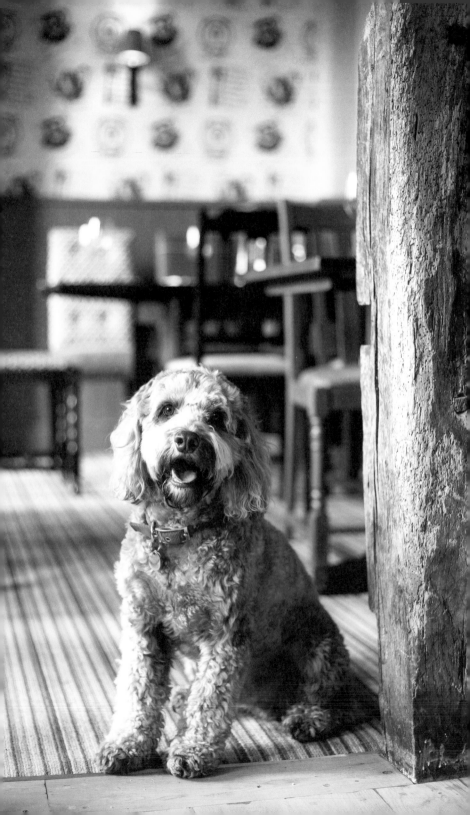

ERIC

Cockapoo

THE DIDSBURY

Where do they sleep?
in his crib at night, and
on the sofa during the day

Favourite things
treats and cuddles

Most dislikes
having his hair brushed,
the vacuum cleaner

Favourite place
Brantwood Park, meeting
other dogs

Favourite drink
water

When not in Pub likes to
chase birds, run on the
beach and go in water

Likes cats or loathes cats?
likes cats but also likes
to chase them

Best trick
walking on his back legs

Favourite toy
any of Ronnie's (my grandson) toys

Favourite treat
Dentastix

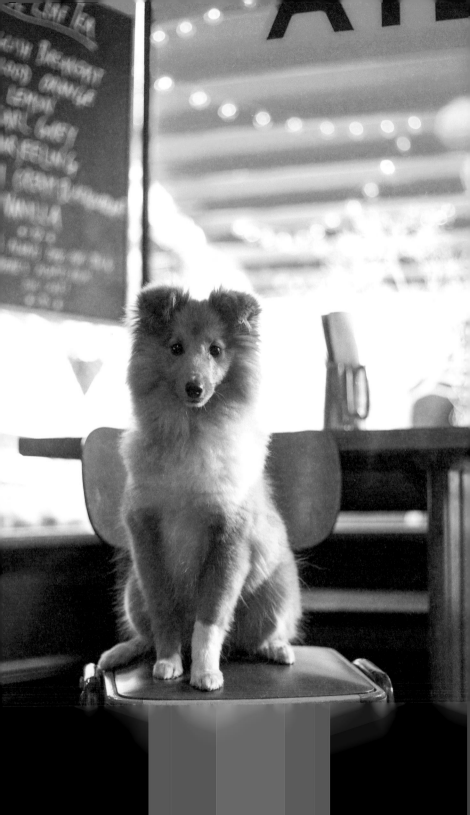

PRIMROSE VOLTA

Shetland Sheepdog (Sheltie)

Where do they sleep?
on mum's side of the bed

Favourite things
her beautiful long nose
– it has its uses!

Most dislikes
the mirror... and mum and dad
daring to fuss another dog!

Favourite place
Barkers of Wilmslow, the local
dog store where she works part-
time as chief treat quality officer

Favourite drink
puddle water

When not in Pub likes to
chase her ball or the cats

Likes cats or loathes cats?
loves... she thinks she is one!

Best trick
is not a performing monkey!
And will shoot you a look to
make sure you know that!

Favourite toy
her squeaky frog (no stuffing left!)

Favourite treat
fish skins

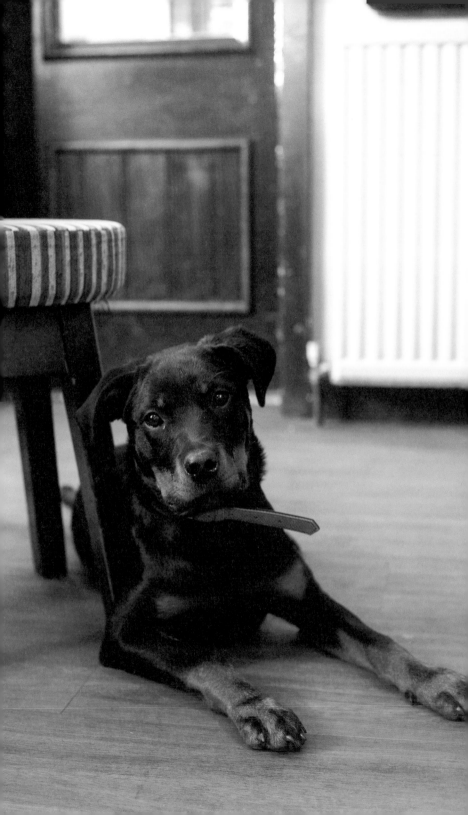

FENNUALA THE BOWLING GREEN

Rottweiler

Where do they sleep?
sofa

Favourite things
being in the meadows

Most dislikes
being alone

Favourite place
my bed

Favourite drink
dog beer

When not in Pub likes to
play with other dogs in
the meadows

Likes cats or loathes cats?
thinks they're angry dogs

Best trick
waiting for treats

Favourite toy
my socks

Favourite treat
slow cooked beef

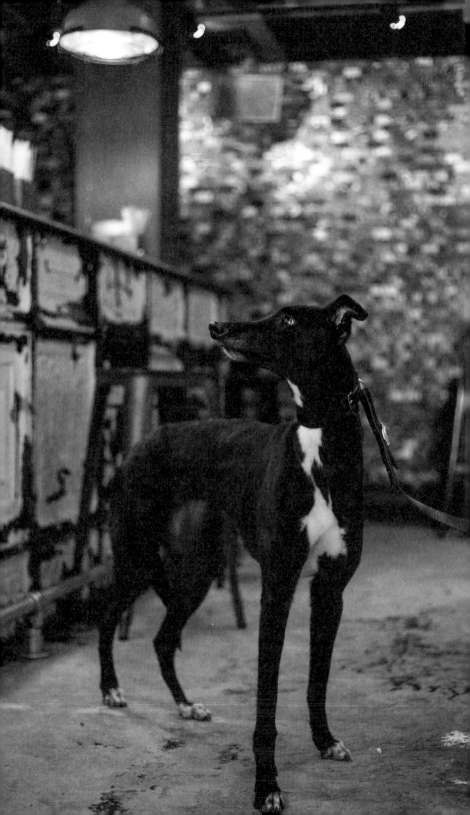

COCO

Greyhound

CANE & GRAIN

Where do they sleep?
in her tweed bed, often
accompanied by Pickles, our cat!

Favourite things
Pickles the cat

Most dislikes
Piccadilly train station (there was
an incident of which we will not
speak... let's just say a lot of tissues
were needed!)

Favourite place
snoozing in her bed

Favourite drink
water, preferably from a river
rather than her bowl...

When not in Pub likes to
lounge around looking
very ungainly

Likes cats or loathes cats?
loooooooves cats! She never raced
because she doesn't have any
chase instinct, but that means
she is very relaxed around cats!

Best trick
zooming around the garden
(she's doesn't have a chase
instinct but she still loves to run!)

Favourite toy
Albert the fluffy stegosaurus toy

Favourite treat
cheese – the smellier, the better

PUBS

Mr Thomas's Chop House
52 Cross Street
M2 7AR

Volta
167 Burton Road
M20 2LN

The Violet Hour
236 Burton Road
M20 2LW

Beggar's Bush
48 Beech Road
M21 9EQ

Dog & Partridge
665–667 Wilmslow Road
M20 6RA

Night & Day
26 Oldham Street
M1 1JN

Brewdog
35 Peter Street
M2 5BG

Folk
169–171 Burton Road
M20 2LN

Albert's Shed
18–20 Castle Street
M3 4LZ

The Font
7–9 New Wakefield Street
M1 5NP

The Metropolitan
2 Lapwing Lane
M20 2WS

Gullivers
109 Oldham Street
M4 1LW

Soup Kitchen
31–33 Spear Street
M1 1DF

Terrace NQ
43 Thomas Street
M4 1NA

Atlas Bar
376 Deansgate
M3 4LY

Briton's Protection
50 Great Bridgewater Street
M1 5LE

The Beech
72 Beech Road
M21 9EG

Common
39–41 Edge Street
M4 1HW

The Parlour
60 Beech Road
M21 2FF

The Whisky Jar
14 Tariff Street
M1 2FF

Wine & Wallop
97 Lapwing Lane
M20 6UR

The Bowling Green
Chorlton Green
Brookburn Road
M21 9ES

Duffy's Bar
398 Barlow Moor Road
M21 8AD

The Railway
3 Lapwing Lane
M20 2WS

Horse & Jockey
9 The Green
M21 9HS

Kosmonaut
10 Tariff Street
M1 2FF

The Lead Station
99 Beech Road
M21 9EQ

Crown & Kettle
2 Oldham Road
M4 5FE

Cask
29 Liverpool Road
M3 4NQ

Dukes 92
18 Castle Street
M3 4LZ

Crane & Grain
49–51 Thomas Street
M4 1NA

Electrik
559 Wilbraham Road
M21 0AE

Dulcimer
567 Wilbraham Road
M21 0AE

Dusk Til Pawn
Steveson Square
M1 1FB

The Woodstock Arms
139 Barlow Road
M20 2DY

The Wharf
6 Slate Wharf
M15 4ST

The Didsbury
852 Wilmslow Road
M20 2SG